# Reflections
# in a
# Looking Glass

"... AND WHAT IS THE USE OF A BOOK," THOUGHT ALICE,
"WITHOUT PICTURES AND CONVERSATIONS?"

—L. C., *ALICE'S ADVENTURES IN WONDERLAND*

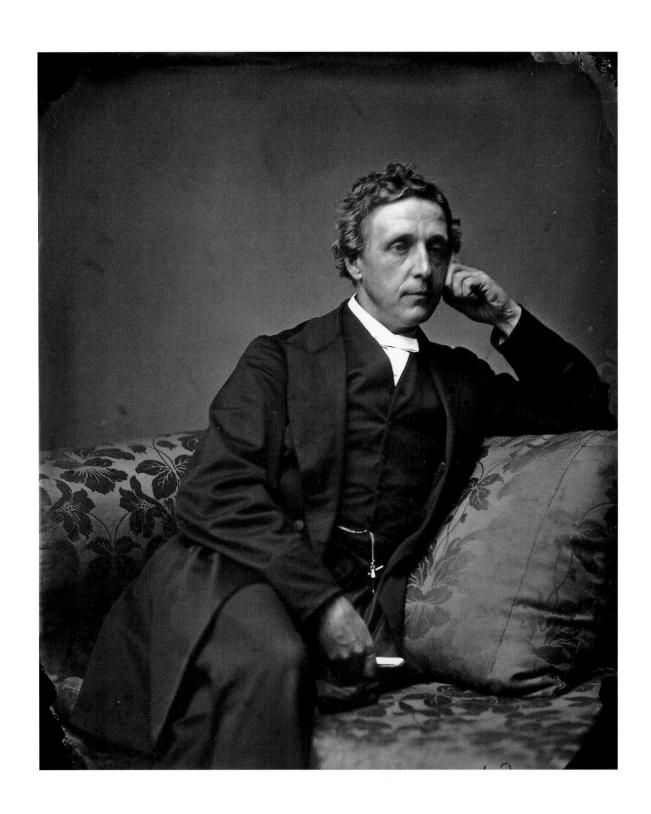

*Charles Lutwidge Dodgson, "Lewis Carroll" (1832–1898).*

# REFLECTIONS IN A LOOKING GLASS

## A Centennial Celebration of
## LEWIS CARROLL, PHOTOGRAPHER

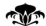

MORTON N. COHEN

*Afterword by*
ROY FLUKINGER

*Postscript by*
MARK HAWORTH-BOOTH

*Photographs from*
THE HARRY RANSOM HUMANITIES RESEARCH CENTER, THE UNIVERSITY OF TEXAS AT AUSTIN

*With selections from*
ALFRED C. BEROL COLLECTION, FALES LIBRARY/SPECIAL COLLECTIONS, NEW YORK UNIVERSITY
GILMAN PAPER COMPANY COLLECTION, NEW YORK ❧ THE NEW YORK PUBLIC LIBRARY, HENRY W.
AND ALBERT A. BERG COLLECTION ❧ THE PIERPONT MORGAN LIBRARY, NEW YORK
PRIVATE COLLECTIONS ❧ THE ROSENBACH MUSEUM & LIBRARY, PHILADELPHIA
THE ROYAL PHOTOGRAPHIC SOCIETY ❧ SCIENCE & SOCIETY PICTURE LIBRARY, LONDON/
NATIONAL MUSEUM OF PHOTOGRAPHY, FILM & TELEVISION, BRADFORD

APERTURE

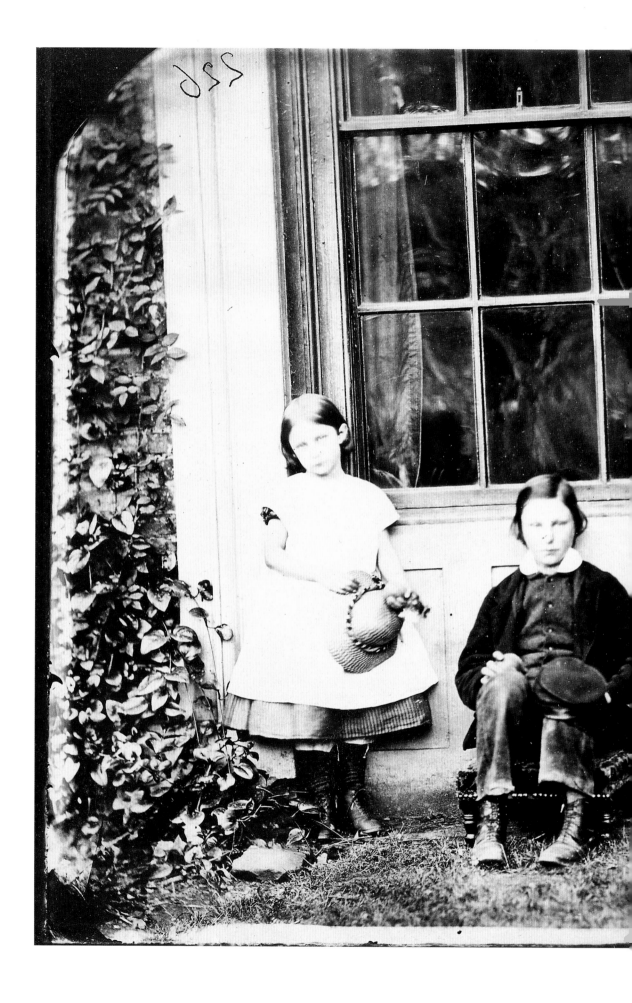

*Four of the Donkin
children, photographed by
Carroll at Barmby Moor
in 1862. Carroll's brother
Wilfred married Alice
Donkin in 1871.*

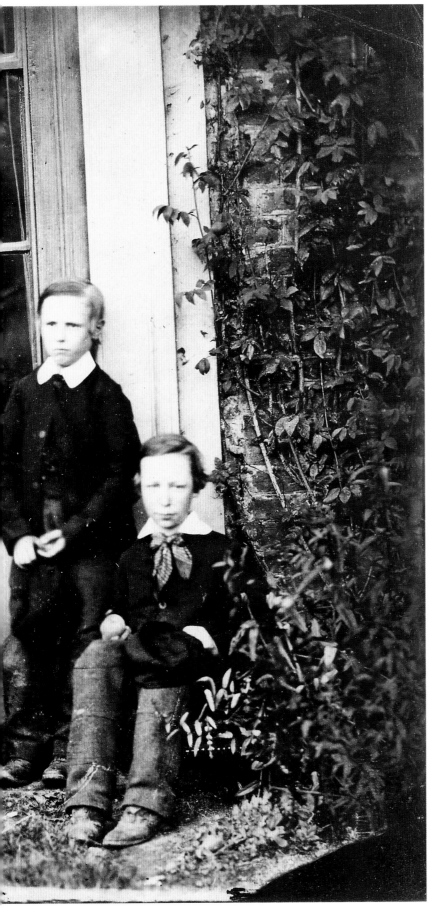

# CONTENTS

*"Rosy Dreams and Slumbers Light" (Xie Kitchin), 1873.*

# LEWIS CARROLL
# PIONEER PHOTOGRAPHER

*Morton N. Cohen*

"My earliest recollections of Mr. Dodgson," one of Lewis Carroll's child friends, Beatrice Hatch, wrote in later years, "are connected with photography. He was very fond of this art. . . . He kept various costumes and 'properties' with which to dress us up, and, of course, that added to the fun. What child would not thoroughly enjoy personating a Japanese, or a beggar-child, or a gipsy, or an Indian?"[1]

Miss Hatch brings back to life the joys of her childhood; her memories of them seem not to have faded as time passed. It is only in childhood, after all, that we experience those tingling sensations of a new experience, when even mundane events take on an aura of magic and mystery, when dressing up, not for dinner or for church, but for masquerade parties or for Halloween, is a journey into an enchanted world. How many adults still feel even a fraction of the exhilaration that Beatrice Hatch and her contemporaries felt as they dressed up in fancy costumes to sit before Lewis Carroll's camera? As William Wordsworth knew so well, we lose that visionary gleam as we mature. What's more, we no longer marvel at the fabulous inventions that have enhanced our daily lives, not least of all photography.

Beatrice Hatch's experience was wondrously special, for Lewis Carroll took those pictures early in the photographic Age of Discovery. And the thrill evolved from much more than the excitement of dressing up; it came from participating in a new exploration comparable to what astronauts must feel today. Some called it science, some called it art; either way, photography in the 1850s offered a voyage into a new realm,

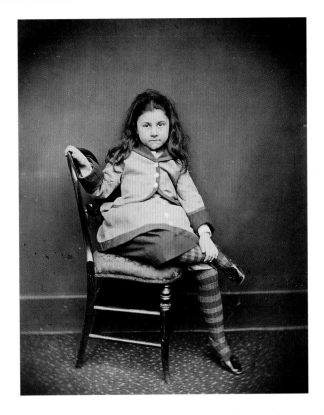

*Beatrice Hatch, March 24, 1874.*

experimental, revelatory, enigmatic–bewitchingly exciting.

And there is Lewis Carroll, introducing those impressionable youngsters to this astonishing phenomenon, conducting those children on their first flights into a world that their parents had never even imagined. They revel in it and never forget it. For some, it remained the most memorable time of their lives.

Dressing up and sitting before Lewis Carroll's camera was, actually, only part of the fun:

. . . much more exciting than being photographed [the real Alice wrote as an elderly woman] was being allowed to go into the dark room, and watch him develop

7

the large glass plates. What could be more thrilling than to see the negative gradually take shape, as he gently rocked it to and fro in the acid bath? Besides, the dark room was so mysterious, and we felt that any adventures might happen there! There were all the joys of preparation, anticipation, and realization, besides the feeling that we were assisting at some secret rite. . . . Then there was the additional excitement, after the plates were developed, of seeing what we looked like in a photograph. . . . It is evident that Mr. Dodgson was far in advance of his time in the art of photography and of posing his subjects.[2]

Ethel Arnold, Matthew Arnold's niece, concurs:

. . . I never catch a whiff of the potent odour of collodion . . . without instantly being transported on the magic wings of memory to Lewis Carroll's dark-room, where, shrunk to childhood's proportions, I see myself watching, open-mouthed, the mysterious process of coating the plate, or, standing on a box drawn out from under the sink to assist my small dimensions, watching the still more mysterious process of development. And then the stories–the never-ending, never-failing stories he told in answer to our never-ending, never-failing demands! He was indeed a bringer of delight in those dim, far-off days, and I look back upon the hours spent in his dear and much-loved company as oases of brightness in a somewhat grey and melancholy childhood.[3]

Lewis Carroll was indeed ahead of his time, as Alice says, not only because he sought to use the new medium in ways that others had not tried, but because he brought to it the sensitivity of the artist that he was. Throughout his life, Carroll searched ardently for beauty–in drawings and paintings, on the stage, in the elegance of mathematical proofs, in the perplexities of the Bible, in

nature, in literature, and particularly in the minds and hearts of children. A photograph for him was a disaster unless it was aesthetically right. He studied and experimented with techniques and evolved rules to help him succeed.

In taking portraits [he wrote], a well-arranged light is of paramount importance . . . as without it all softness of feature is hopeless. . . . [When taking groups, one must give] to the different figures one object of attention. . . . In single portraits the chief difficulty . . . is the natural placing of the hands; within the narrow limits allowed by the focussing power of the lens there are not many attitudes into which they naturally fall, while, if the artist attempts the arrangement himself he generally produces the effect of the proverbial bashful young man in society who finds for the first time that his hands are an encumbrance, and cannot remember what he is in the habit of doing with them in private life.

. . . A common fault in choice of view is getting the principal object exactly into the centre, or . . . so near to it that the calculating faculty is at once aroused instead of the imaginative, and the spectator longs for a foot rule to ascertain whether the picture is exactly bisected or not.

. . . it is in grouping that the chief difference lies between the artist and the mere chemical manipulator. . . . One other fault . . . [is] the attempting of manifest impossibilities. Some instances of this may be found . . . where, by taking a point of view too near for the power of the lens, a disagreeable pyramidal effect is given to the [objects being photographed]. . . .[4]

With all these considerations, and others, in mind, Lewis Carroll made the striking photographs that appear here.

But who was Lewis Carroll, besides the author of *Alice's Adventures in Wonderland* and *Through the Looking-Glass*? His real name was Charles Lutwidge Dodgson, and he was born on January

Opposite: *After Carroll first told the story of Alice's adventures to the three Liddell sisters on the memorable river picnic, Alice pleaded with him to write it down for her. He obliged in his distinctive script and supplied his own illustrations. The early version was called* Alice's Adventures Under Ground.

"Everybody says 'come on!' here," thought Alice, as she walked slowly after the Gryphon; "I never was ordered about so before in all my life — never!"

They had not gone far before they saw the Mock Turtle in the distance, sitting sad and lonely on a little ledge of rock, and, as they came nearer, Alice could hear it sighing as if its heart would break. She pitied it deeply: "what is its sorrow?" she asked the Gryphon, and the Gryphon answered, very nearly in the same words as before," it's all its fancy, that : it hasn't got no sorrow, you know: come on !"

So they went up to the Mock Turtle, who looked at them with large eyes full of tears, but said nothing.

"This here young lady" said the Gryphon;

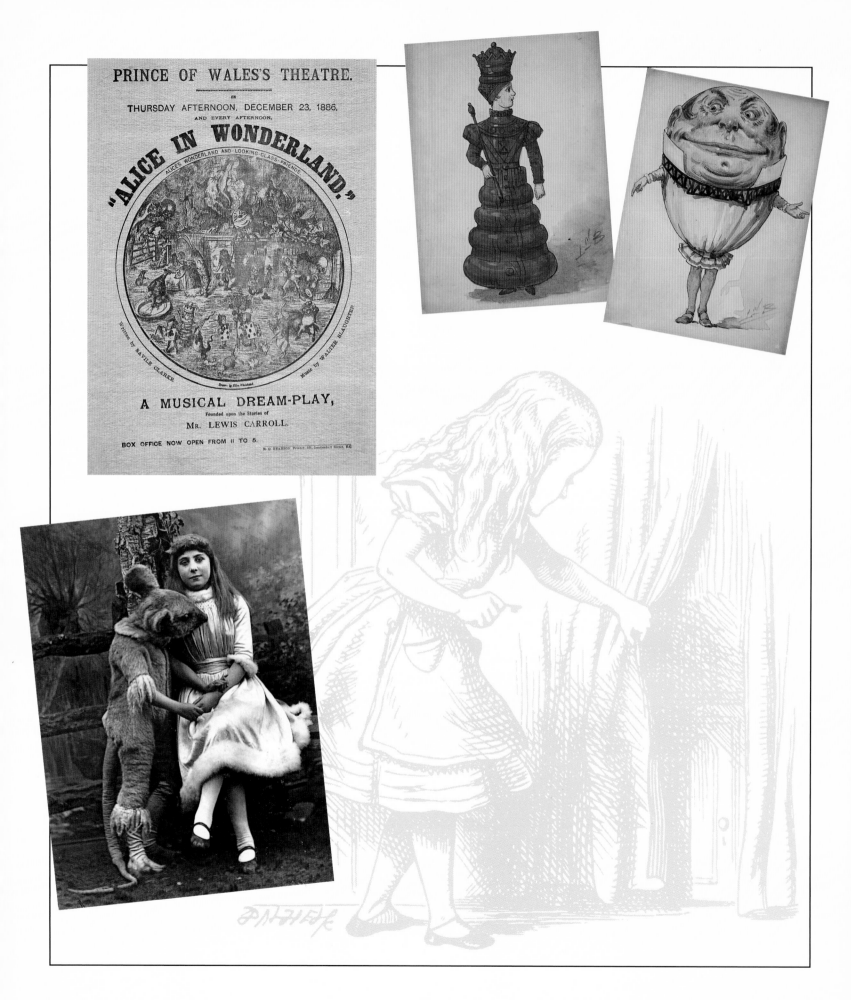

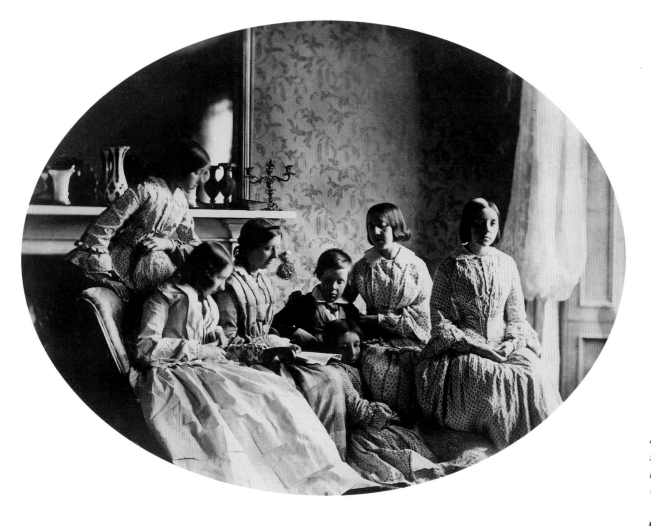

*Six of Carroll's seven sisters and his youngest brother, Edwin, in the Old Rectory, Croft.*

*Opposite:* It was inevitable that the Alice stories would be adapted for the stage, and the first professional production, dramatized by Henry Savile Clarke, opened at the Prince of Wales Theatre in London for Christmas 1886. The costume designs (top right) were by Lucien Besche. Phoebe Carlo played Alice, Dorothy d'Alcourt was the Dormouse. Carroll thought Phoebe made "a splendid Alice. But the Dormouse is simply wonderful."

27, 1832, at Daresbury in Cheshire, where his father was Perpetual Curate. In 1843, the senior Dodgson was made Rector of Croft, Yorkshire. Charles, third of eleven children and the eldest son, enjoyed a happy and lively, if disciplined, upbringing. His father provided a solid grounding in mathematics and Latin as well as religion even before the boy entered Richmond School at age twelve. From Richmond he went to Rugby, where the rough-and-tumble life of the public school caused him some anguish. After Rugby he went to Christ Church, Oxford, where he lived and worked until his death, 47 years later.

From 1852 he was Student (the equivalent of Fellow at other colleges) and from 1855 on Mathematical Lecturer. In 1861 he was ordained deacon. But he chose not to take a priesthood or a curacy; he was deaf in his right ear and stammered, handicaps not conducive to parish work. Besides, he was a trained mathematician-logician, hoping to teach Oxford undergraduates and to push logical thinking beyond the boundaries recognized in his time. He was pleased when the Bishop of Oxford assured him that his clerical status and professional avocation were compatible. He remained a Christ Church mathematics lecturer for a quarter of a century, until shortly before his fiftieth birthday, wrote a variety of texts to help students meet the university's mathematical requirements, and published other more arcane studies, many grounded in the works of his idol Euclid. For the sheer pleasure of introducing students to mathematics and logic, he taught at a number of Oxford and Eastbourne colleges and schools as a volunteer.

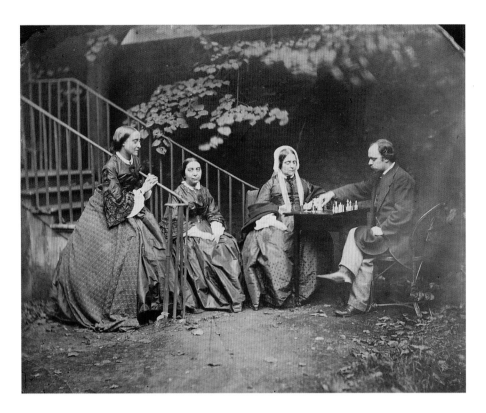

*Dante Gabriel Rossetti plays chess with his mother, Frances, as his two sisters look on, October 1863.*

their welfare. In the summer he took lodgings by the sea, usually at Eastbourne, for working holidays.

Carroll was genuinely religious, but he stood apart from the theological storms raging around him. He never married, though he probably wished to and would no doubt have made a loving husband and doting father had he done so. He claimed generally to be happy, but at least one observer guessed that he was a "lonely spirit and prone to sadness."[5] He lived an orderly, careful life, ate little, and chose hard work as his road to salvation. He was a compulsive record-keeper: his letter register showed that in the last thirty-five years of his life he sent and received no fewer than 98,721 letters.

Contrary to myth, he was not a shy recluse sequestered behind college walls. He traveled frequently in Britain, sometimes with his cumbersome camera in tow; he could be seen in London theaters, art galleries, even in the corridors of power; and he hobnobbed with artists, writers, and actors. He left Britain only once, accompanying his friend the theologian Henry Parry Liddon across Europe on a mission to Russia, where Liddon explored the possibilities of rapprochement between the Eastern and Western Churches.

He was about six feet tall, slender, had either gray or blue eyes—observers disagree—wore his hair long, and "carried himself upright, almost more than upright, as if he had swallowed a poker."[6] He dressed customarily in clerical black and wore a tall silk hat, but when he took Alice and her sisters, the daughters of his college dean, H. G. Liddell, rowing on the river, he wore white flannel trousers and a hard white straw hat. He had no beard or moustache. He wore no spectacles, although he used a magnifying glass freely. He had a pleasant speaking voice. Unfortunately we have no recording of it, although wax cylinders made at the time of Tennyson and others can be heard today. He had a tolerably good singing voice which he did not mind using. He enjoyed a glass of wine. He sometimes talked to himself. Instead of birthday

He had eclectic interests. He was drawn to gadgets and invented a few himself. All matters mechanical, technological, medicinal, and scientific fascinated him. He would have embraced enthusiastically the fax machine and the computer with all its ramifications: e-mail, CD-ROMs, the Internet, the World Wide Web. He would, in fact, have made a superb Web-Master at Christ Church had such a position existed. He came to photography early in its history, and an array of celebrities sat before his lens, including Crown Prince Frederick of Denmark; Queen Victoria's youngest son, Prince Leopold; John Everett Millais; the Rossettis; John Ruskin; Lord Salisbury, the Prime Minister; Tennyson; Charlotte M. Yonge; George MacDonald; F. D. Maurice; Ellen Terry and her famous actor siblings.

Carroll's ties to the stage ran deep. He wrote plays and acted in amateur theatricals. He spoke out courageously for the professional theater as a source of wholesome entertainment and education in an age when the Church opposed it.

When his father died in 1868, Carroll rented a house called "The Chestnuts" at Guildford in Surrey for his unmarried sisters and younger brothers and went there regularly, solicitous of

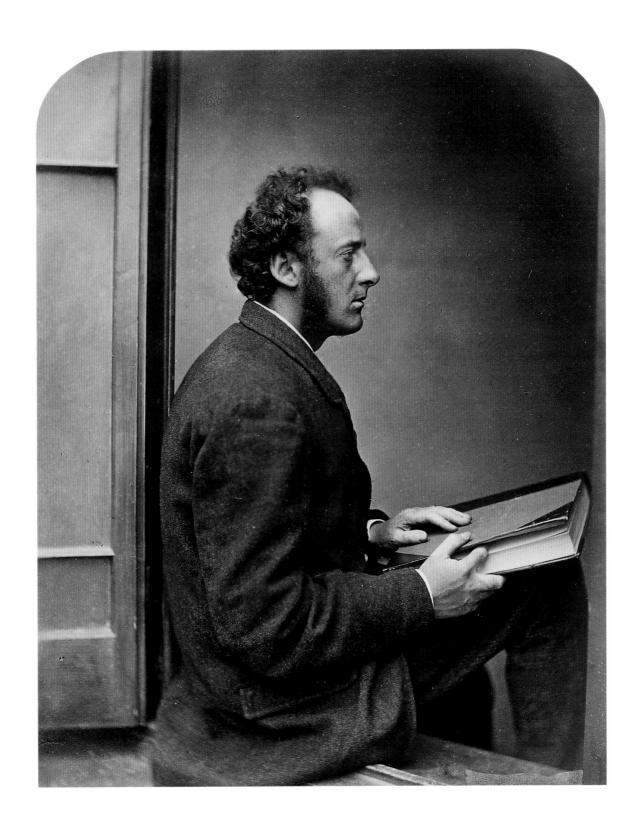

*Sir John Everett Millais (1829–1896), the eminent and popular painter, one of the founders of the Pre-Raphaelite movement. When, in April 1864, Lewis Carroll went, with a letter of introduction from William Holman Hunt, to meet Millais, he wrote in his diary, "He was very kind, and took me into his studio . . . and sent for his children— 2 boys, and 3 girls. . . ." Carroll and the Millais family became friends. This portrait was taken on July 21, 1865.*

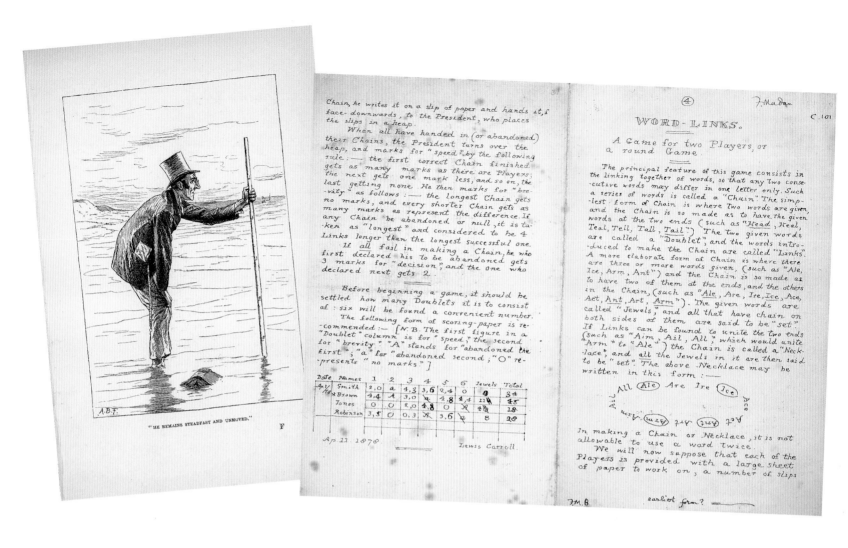

"HE REMAINS STEADFAST AND UNMOVED."

F

*Among Carroll's many inventions is the game Word-Links, this pre-published version in his own hand. The American artist Arthur Burdett Frost illustrated some of Carroll's published verse and games. "He remains steadfast and unmoved" appeared in Carroll's puzzle book entitled* A Tangled Tale.

presents he preferred to give un-birthday presents because he could give them so many more times in the year. Tuesday, he said, was his lucky day.

He was interested in many branches of science, particularly medicine, and was a member of the Society for Psychical Research. Art and music were two of his delights, and he was fond of quotations. He disliked physical sports but was known to play croquet. He went on long walks, sometimes covering twenty-three miles in a day. He was orderly in all things. While many attest to his kind and courteous nature, he could be rude to those who offended his high standards of propriety. Certainly he stomped out of theaters when he found anything on the stage irreligious or otherwise offensive. He once reprimanded the Bishop of Ripon for including in a Bampton lecture an anecdote that elicited laughter from the audience. He planned but never completed a

volume of Shakespeare plays especially for girls that would have out-bowdlerized Bowdler.

He so resented the Duke of Venice's speech at the end of *The Merchant of Venice* that required Shylock to abandon his faith and become a Christian that he wrote to Ellen Terry, after seeing her and Henry Irving perform the play, asking her to delete the Duke's lines from future performances: "it is a sentiment that is entirely horrible and revolting to the feelings of all who believe in the Gospel of Love."[7]

He was an anti-vivisectionist and denounced blood sports. He valued his privacy, hated the limelight, and concealed the true identity of Lewis Carroll. He was known to leave tea parties if his hostess revealed his pseudonym or fussed over him. He was unselfish and generous. He helped support his sisters and brothers, other relatives, friends, and even strangers. He was always willing to take on new students, and he

was ready to try to help young and old with spiritual problems.

Carroll was constantly involved in extramural (if not worldly) affairs. Essentially conservative, he nonetheless fought for reforms that won for him and his fellow Christ Church dons a voice in college matters. He frequently showered members of the college and university with broadsheets and pamphlets in prose and verse which he had privately printed, on a multiplicity of subjects from opposition to cricket pitches in University Parks to a spoof, dripping with irony, of the wooden cube–he called it a "meat safe"–that Dean Liddell had erected atop Tom Quad's Great Hall staircase to house bells removed from the Cathedral. He also dispatched, from his Christ Church aerie, letters and articles to a string of periodicals. The subjects vary widely and include Gladstone and parliamentary cloture, vivisection, hydrophobia, education for child actors, and logical paradoxes.

Throughout his mature life, Dodgson sought close friendships with a coterie of female children. In spite of some contemporary gossip and suspicions about his motives, all the evidence we have suggests that these were innocent affairs, grounded in an aesthetic that Dodgson inherited from William Blake and the Romantics. He was convinced that the objects of his worship were children's beauty and purity. He loved the child's unspoiled, untutored naturalness and what he saw as her closeness to God. By some magical combination of memory and intuition, he understood what it was like to be a child in grown-up society. He could instinctively speak a child's language, capture his young friends' interest, engage them in conversation, move them, and, best of all, evoke peals of laughter from them. He treated children, both in his books and in real life, as equals. For his part, he lost his awkwardness–and, some say, his stammer–in their presence.

These fairy creatures sparked his creative energies, and for them he composed his masterpieces: *Alice's Adventures in Wonderland* (1865),

*Through the Looking-Glass and What Alice Found There* (1872), *The Hunting of the Snark* (1876), *Sylvie and Bruno* (1889), and *Sylvie and Bruno Concluded* (1893). He doted on children and devoted considerable time, energy, and money to doing things for them. In a letter to the father of one of his child friends, he wrote in 1877: ". . . the pleasantest thought I have, connected with Alice, is that she has given real and innocent pleasure to children."[8]

He also invented a myriad of games and puzzles for his child friends and published many of them in periodicals and in books to edify and amuse an army of children he did not personally know. Among these works are *Word-Links* (1878), *Doublets* (1879), *Mischmasch* (1882), *A Tangled Tale* (1885), *The Game of Logic* (1886), and *Syzygies and Lanrick* (1893).

Two of his three volumes of poetry, *Phantasmagoria and Other Poems* (1869) and *Rhyme? and Reason?* (1883), contain witty narratives and nonsense lyrics similar to those in the *Alice* books, the *Snark*, and in the *Sylvie and Bruno* volumes, but they are encumbered by more than a sampling of tedious and uninspired serious verse. His last volume of verse, *Three Sunsets and Other Poems*, published posthumously, contains only serious verse.

Many of Dodgson's publications were the work of a professional mathematician-logician. These include: *A Syllabus of Plane Geometry* (1860); *An Elementary Treatise on Determinants with Their Application to Simultaneous Linear Equations and Algebraical Geometry* (1867); *Euclid and His Modern Rivals* (1879); *Curiosa Mathematica* (1888, 1893); and *Symbolic Logic, Part I* (1896).

Dodgson's reputation as an original mathematical thinker has risen in recent years, a reappraisal owed in large part to two books: *Symbolic Logic, Part II*, the book that Dodgson virtually completed before he died in 1898 but that remained unpublished until 1977; and the collection of the mathematical pamphlets that he had published over his mature life.[9]

We lived beneath the mat
Warm and snug and fat
But one woe, & that
Was the cat!
To our joys
a clog, In
our eyes a
fog, On our
hearts a log
Was the dog!
When the
cat's away,
Then
the mice
will
play,
But, alas!
one day, (So they say)
Came the dog and
cat, Hunting
for a
rat,
Crushed
the mice
all flat,
Each
one
as
he
sat
Underneath the mat
Warm and snug and fat—Think of that!

*The Mouse's Tale from*
Alice's Adventures in
Wonderland.

"Oh, Bobby, Bobby! What ever _is_ the matter?"
"Why, nurse, here's the cat a fighting! He's been and thrashed Sam, and he's pitched half the furniture out o' winder, and —— take _that_, you brute!"
"Miaouw! Pfsh! Pfsh!"

Ch. Ch. Oxford.
Dec. 19 /93

Dear Mr. Tison

Your solution shows what an awful amount of trouble it causes to try an algebra problem by arithmetic.

Let $x$ = No. of nuts.

Let $\theta = \frac{3}{4}$

1st soldier leaves $\theta x - \theta$

2nd --- $\theta^2 x - (\theta^2 + \theta)$

&c

100th --- $\theta^{100} x - (\theta^{100} + ... + \theta)$

$= \theta^{100} x - \theta \cdot \frac{1 - \theta^{100}}{1 - \theta}$

$= \theta^{100} x - 3 \cdot (1 - \theta^{100})$

$= \theta^{100}(x + 3) - 3$

Now $(x+3)$ must be least No. which will divide by $4^{100}$

i.e. it is $4^{100}$

$\therefore x = 4^{100} - 3.$ Ans.

Thanks for 'pigs': but I have long known it.

Very truly yours,
C.L. Dodgson

THE FOOLISH MILLER

But he did more. In a sense he turned mathematics and logic on their heads, adding humor to studies that are deadly serious. Specialists take warmly to the added wit in almost all of Dodgson's mathematical writings. The exercises he invented, the paradoxes he posed, the examples he supplied are all couched in drama and suspense and are infused with an intrinsic sense of fun. Professional mathematicians the world over smile irrepressibly when they refer to Dodgson's "Barber-Shop Paradox" or to his "Paradox of Achilles and the Tortoise." Even his syllogisms can be amusing. Here is one:

All lions are fierce;
Some lions do not drink coffee.
Conclusion:  Some creatures that drink coffee are not fierce.

Another:

No Professors are ignorant;
All ignorant people are vain.
Conclusion:  No Professors are vain.

Or a third:

All uneducated people are shallow;
Students are all educated.
Conclusion:  No students are shallow.

Even this description of Dodgson's labors fails, however, to do him justice. He contributed significantly to the history of voting theory[10] and concocted new rules for making lawn tennis competitions more fair.[11]

Though Lewis Carroll never held a curacy, from time to time he took Sunday service for others. On at least two occasions, in fact, a university congregation filled St. Mary's, Oxford, to capacity to hear him preach. He also did some parochial work, helping those in need, consoling the sick. For more than nine years, he was Curator of Christ Church Senior Common Room, an arduous job requiring close attention to detail and keen business acumen.

On February 17, 1880, a most remarkable entry appears in Dodgson's *Diaries*: "Sent to the Dean the paper in which I propose to the 'Staff-Salaries Board' that, as my work is lighter than it used to be, I should have £200 instead of £300 a year." Then he adds: "Offer was accepted March 11." What university teacher today would ask to have his salary reduced?

He could be witty and engaging in person as well as in print, but he could also be censorious, snobbish, even prickly. Perhaps his most important attribute was his forthright faith. He was a true Christian who knew his Bible, thought carefully about moral questions, lived a righteous, if somewhat guilt-ridden life troubled by small transgressions and forces he saw within himself which he could not reconcile with his faith. He was at heart a generous man, a romantic who believed that love makes the world go round. Here is how he put it to one of his child friends:

Photographs are very pleasant things to have, but *love* is the best thing in the world. . . . Of course I don't mean it in the sense meant when people talk about "falling in love": that's only *one* meaning of the word, and only applies to a few people. I mean in the sense in which we say that everybody in the world ought to "love everybody else." But we don't always do what we ought. I think you children do it more than we grown-up people do. . . .[12]

To improve his drawing, he studied art techniques, attended art classes, mixed with artists, and regularly went to art exhibitions in Oxford and London. But eventually he had to face the hard facts, and at one point, perhaps even before John Ruskin told him that he had not enough talent to become a real artist,[13] he decided that his meager skill was not good enough for him to illustrate his own books. Failing as an artist was one of the real disappointments of his life and may have been a strong motive for taking up photography. It was a happy decision, for his results in the new medium were so successful that he felt justified in inscribing some of the photographs he gave to friends as "from the Artist."

Opposite: *Carroll's drawings may not be great art, but they bear a charm of their own. These two early drawings probably illustrated stories for one of the eight Dodgson family magazines.*

*Many of Carroll's letters concern specific mathematical problems and methods of solving them. Here (opposite left) he writes to a Christ Church undergraduate, Francis Geoffrey Fison.*

*"And what do you think I am going to have for my birthday treat?" he wrote to a young friend in 1882. "A whole plum-pudding! It is to be about the size for four people to eat: and I shall eat it in my room, all by myself! The doctor says he is 'afraid I shall be ill': but I simply say 'Nonsense!'"*

Artistry indeed is what distinguishes Lewis Carroll as a photographer, and it sets him apart from the hordes of other early practitioners. In fact, by the time he first acquired his camera, photography was already a popular pastime. The "glass house," where photographs were taken, was almost as common in the Victorian landscape as the television aerial in ours, and taking and looking at photographs was a recreation like television viewing today. Even Queen Victoria and Prince Albert set up a darkroom at Windsor Castle just a year after Carroll bought his camera.

Carroll began taking photographs in 1856, when he was twenty-four, already a don. His favorite uncle, Skeffington Lutwidge, visited the family in Yorkshire with his camera and took photographs of them all. Carroll was intrigued. He must also have been encouraged by his Christ Church colleague and chum, Reginald Southey, who also owned a camera and was taking photographs. During the Easter vacation that year, Carroll, in London, bought his camera and lens, and the rest is history. He arranged his photographs in albums, with appropriate indexes, he numbered his negatives and kept a photography register. In turn, he tried his hand at landscapes, architecture, a human skeleton, a fish skeleton; he photographed drawings and sculptures. But, in time, he settled on portraiture: he photographed his family, Oxford colleagues, then London friends and luminaries.

Carroll never had a hobby; when he grew interested in a subject, he worked hard to become a specialist, and so it was with photography. With determination, he sought out worthwhile subjects, especially handsome, striking, beautiful sitters. He arranged them and the background carefully. He had a knack for making people enjoy sitting still for the eternity required, for making them feel relaxed, not fidgety. Especially with children, he used his ebullience, charm, volubility, and his treasure trove of anecdotes to divert their attention from the mechanics of picture-taking. He collected and examined other artists' work. When he went to the Exhibition of the British Artists in London in April 1857, he noted: "I took hasty sketches on the margin of the Catalogue of several of the pictures, chiefly for the arrangement of hands, to help in grouping for photographs."[14] He developed an eye for proportion and balance. When a friend sent him a photograph of his daughter, he returned it asking for a cropped copy, "that I may have her *without her feet!* The artist has managed his lens badly, and has magnified them: no English child ever had such huge feet!"[15]

Lewis Carroll is often paired with Mrs. Julia Margaret Cameron as one of the two distinguished photographers of Victorian children. Their photographs are, however, extremely different. Carroll's devotion to natural realism clashed with Mrs. Cameron's shimmery impressionism. When Carroll visited the Photographic Exhibition in June 1864, he "did *not* admire Mrs. Cameron's large heads taken out of focus" and wrote one of his sisters that some of them were "merely hideous."[16] Needless to say, Mrs. Cameron returned the compliment. To the poet Henry Taylor she wrote: "Your photograph by Dodgson I heard described as looking like 'a sea monster fed upon milk.' . . . The Tennysons abhor that photograph."[17] The two, nonetheless, remained friendly. Carroll kept his flights of fancy for his story telling. In photography, by and large, he strove to preserve the present, to catch the fleeting face of beauty and record it for posterity.

By no measure did Carroll work in an era of easy, instant photography. To take his photographs, he needed a darkroom at hand before and after he took his picture. He first had to prepare his sitter for the "take"; then, when all was ready, he darted off to his darkroom to prepare the "plate" (film did not come into use until the 1880s). He had to pour collodion, a gummy solution of guncotton in ether that dries rapidly, usually onto an 8-by-10 inch glass plate which he had rubbed and polished like a conscientious waiter with a wine glass. In pouring the collo-

dion, he had to make sure that he coated the glass evenly and completely and that no foreign specks or liquid touched it. Then, working quickly, he sensitized the plate by dipping it into a silver nitrate solution, again making sure that the liquid spread evenly over the surface. That done, he could take the picture, providing, of course, that no accident occurred on the way from the darkroom to the camera and back. If the wet plate brushed against his cuff or smeared against a curtain, it was ruined; if he bumped up against anything, or if, in moving to and from the camera, he stirred up a cloud of dust and particles settled on the wet plate, he had to begin again. The process was intricate and further complicated by the need to hurry: the collodion plate had to remain wet throughout the various stages; "wet collodion" was no misnomer.

As soon as Carroll exposed the plate (by lifting a cap from the front of his camera and replacing it after a prescribed number of seconds), he had to rush, plate in hand, back to the darkroom to develop it on the spot, and after developing it in one carefully prepared solution, he had to "fix" it in another. If all went smoothly, if the sitter remained stone-still for, say, the forty-five seconds required, if the daylight was strong enough, if the temperature had not changed significantly, if the chemicals were pure, potent, and properly applied, if dust kept its distance, then perhaps Carroll had a negative that might please him. But successful or not, he was a marked man—he emerged from his darkroom with black stains on his hands and probably on his clothing. The chemicals splashed when he used them, and he had to use his hands to get the plates into the liquid solutions. The black stains, coupled with the fact that they occurred in a darkroom, earned for photography the sobriquet "the black art."

But even now Carroll was not finished. He had yet to hold the glass plate before a hot fire until it was evenly heated, then pour varnish over it, and allow it to drain and dry. Finally,

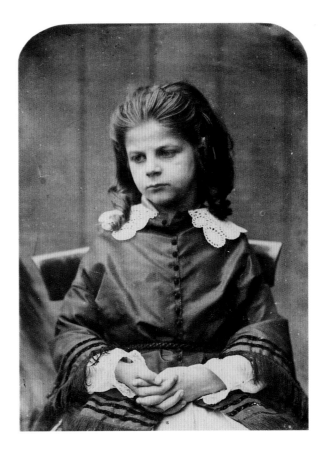

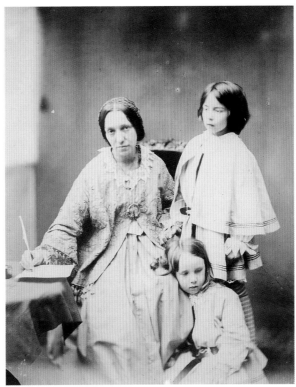

*Agnes Grace Weld sat for Carroll and for Julia Margaret Cameron. Below is Carroll's photograph of Cameron with two of her sons, ca. 1858.*

19

when he had a negative fixed and varnished, he could make a positive print. Victorian photograph albums are often testimonials not so much to the marvels of photography as to photographic failures. That Carroll achieved so many clear, unblemished results in perfect focus says much for his technical ability, his efficiency, and his artistry.

In our day, everyone is a photographer. Our picture-taker has a small camera or a camcorder slung over his shoulder or a disposable camera in his pocket. He shoots as he wishes and gets, if not edifying, certainly adequate results. Carroll's photographic equipment, by contrast, was extensive and unwieldy. To photograph landscapes, he packed and carted about the countryside his camera, trays, bottles, a thermometer, chemicals, and a tent for a darkroom. To photograph friends and dignitaries, he took all this paraphernalia to London and imposed upon his hosts to allow him to set up a darkroom and studio. Through a family friendship with C. T. Longley, the Archbishop of Canterbury, Carroll was even able to use Lambeth Palace, with its rich architectural backdrop, as a photographic venue.

He soon achieved recognition as an art photographer, and two years after he purchased his camera, four of his pictures went on show in the fifth annual exhibition of the Photographic Society of London, no small accomplishment for a neophyte who was not even a member of the Society. When word of Carroll's stunning photographs spread through Oxford, parents eagerly consented to allow him to "take" their children, and proud mothers were soon leading their little darlings through Tom Quad and up the stairs to Carroll's rooms. Carroll was elated. Photography provided instant access to his heart's delight, to the acquaintance, converse, and, in many cases, prolonged and affectionate friendships with beautiful, pure, unaffected young female friends. His portraits of adults are distinguished, but in his photographs of children, his art reaches its apogee.

But he did not photograph anyone and everyone, only "well-made children who have a taste for being taken. . . . I should decline the offer of others," he wrote, "as I think such pictures would be unpleasant."[18] He was also especially careful to insure that the children felt comfortable with him and wanted to be photographed. He invited one mother to bring her daughters round for a visit, "*not* [to] be photographed then and there (I never succeed with strangers), but to make acquaintance with the place and the artist, and to see how they relished the idea of coming, another day, to be photographed."[19]

When he knew that the children felt at ease with him, he went to work, gently and carefully, using all his natural charm and wit to achieve a pleasant air. He strove to capture his subjects as they appeared in real life, almost as though taken unawares. "He could not bear dressed-up children," one observer later wrote, "but liked them to be as natural as possible. He never let them pose . . . and it did not matter a bit if their hair was untidy; in fact, it pleased him better."[20] His experience with the theater led him to value stage props, and he used them liberally: a book, a lens, a croquet mallet, a table, a bicycle, a mirror, a hat, a doll, a basket, a column, a trellis, a flower. He disliked elaborate backdrops and favored a stone or brick wall, a simple blanket, a cloth, or a plain curtain, a flight of stairs, a classical pillar, a Gothic arch.

Although he did not invent any photographic material or procedures, he did experiment with different techniques and sought innovations. He created story photography: a child portrayed in a nightdress, mouth set grim, hair disheveled, a brush and mirror in her hands—with the title "It Won't Come Smooth"; Alice Liddell and her two sisters, one holding a cherry out for another to reach with her lips, titled "Open Your Mouth and Shut Your Eyes." Others depict characters from literature and lore: the Beggar Maid, Little Red Riding Hood, a tableau vivant entitled "St. George and the Dragon," a youngster as Viola in *Twelfth Night*. He intentionally

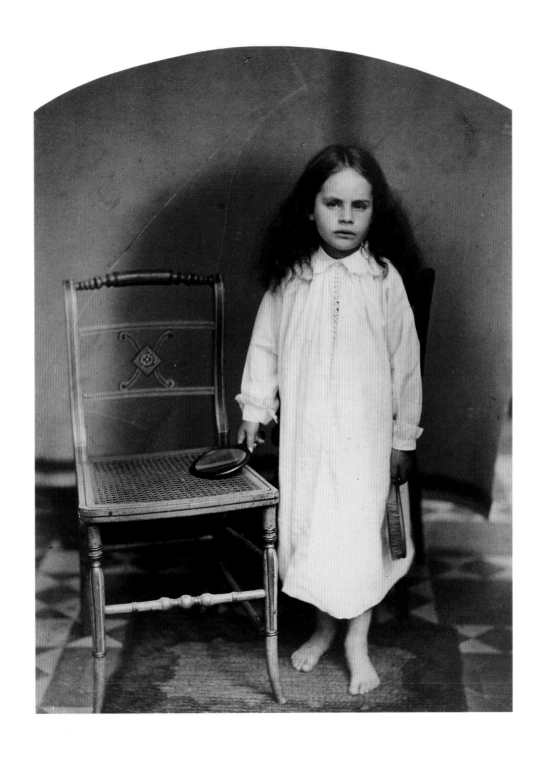

*"It Won't Come Smooth": Irene MacDonald in one of Carroll's "story" photographs, taken July 31, 1863. The child can't get her hair to behave.*

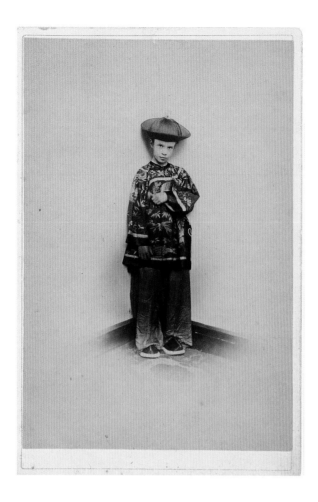

Right: *Ethel Arnold in Chinese dress. Julia Frances (1862–1908) and Ethel Margaret (1866–1930) Arnold were the daughters of the younger Thomas Arnold of Oxford, granddaughters of Dr. Arnold of Rugby and nieces of Matthew Arnold. Carroll was a friend of the Arnold family and photographed these two daughters frequently.*

Opposite: *Annie and Frances Henderson in Robinson Crusoe costume, ca.1880. On July 18, 1879, Carroll wrote in his diary: "Mrs. Henderson brought Annie and Frances. I had warned Mrs. Henderson that I thought the children so nervous I would not even ask for 'bare feet,' and was agreeably surprised to find they were ready for any amount of undress, and seemed delighted at being allowed to run about naked. It was a great privilege to have such a model as Annie to take: a very pretty face. . . ." The sisters pictured as hand-painted castaways were Annie Grey Wright Henderson (1871–1951) and Hamilton Frances (b. 1872); their father was Patrick Wright Henderson (1841–1922), Fellow of Wadham College.*

double-exposed a group of children in one entitled "The Dream," with a lad appearing as a ghost. "On one occasion," a friend recalled, "he was anxious to obtain a photograph of me as a child sitting up in bed in a fright, with her hair standing on end as if she had seen a ghost. He tried to get this effect with the aid of my father's . . . electrical machine, but it failed, chiefly I fear because I was too young quite to appreciate the current of electricity that had to be passed through me."[21]

The adventures shared in taking photographs, of deciding on the pose, arranging the clothing, placing the hands, adjusting the limbs, seeking the right facial expression—all became an elaborate game the children and Carroll played together and enjoyed. Carroll, for his part, told the little ones jokes and teased them as he went about the elaborate ritual; the children were thrilled, flattered by the attention he showered upon them. The photographer-critic Brassaï,

noting the "utter delight" that Carroll's photography provided his young sitters, found in "every picture" the "unspeakable joys of the time spent in this pleasant intimacy."[22]

While Carroll used all manner of dress for his sitters—ragged garments, party frocks, stage costumes—he also took them with no dress at all. Not right away, to be sure. First, he took a number, besides Alice Liddell, as beggar children with bare feet; then some wearing nightdresses in bed or on settees. Then, on July 8, 1866, he took "a good many" photographs of little Ella Monier-Williams, the daughter of a Professor of Sanskrit and the child who could not bear those electric shocks, "pictures with no other dress than a cloth tied round her, savage fashion."[23]

In May 1867, eleven years after he had acquired his camera, he managed to dispose of garments altogether. "Mrs. Latham [an Oxford neighbor] brought Beatrice and I took a photograph . . . of Beatrice alone, *sans habillement*."[24] In the next thirteen years, several nude youngsters stood, sat, or lay down before his camera, and not only in his Oxford studio. While at his family home in Guildford in 1869 for instance, he visited some neighbors: "Took camera, sofa, etc., into the Haydons' garden," he writes, "and did a number of photos, Tommy, Ethel (2 of the latter undraped)."[25]

Always mindful of a child's sensitive nature, he was even more so when taking nude photographs. He himself would not, for instance, undress or dress a child, but insisted that a mother or some other female adult perform the task. When he engaged Gertrude Thomson to draw some nudes for him, he sent her this caution: ". . . please do not draw . . . [the child model], nude, for my pictures, if she has any scruple *whatever*, on the score of modesty. I'm sure a child's instincts, of that kind, ought to be treated with the utmost *reverence*. And if I had the loveliest child in the world, to draw or photograph, and found she had a modest shrinking (however slight, and however easily overcome) from being taken nude, I should feel it was a

solemn duty, owed to God, to drop the request *altogether.*"[26]

But Carroll met with willing parents and eager children. Annie and Frances Henderson, of Oxford, posed as two castaways on an island. Annie's daughter wrote some years ago: "My mother was the eldest of three girls, all of whom adored Lewis Carroll. . . . Annie and Frances had gone to visit him with their father and spent the afternoon 'dressing up.' They heard him say how much he would like to photograph them in the nude. They promptly hid under the table, which had a cloth nearly reaching to the ground, and emerged with nothing on, much to the amusement of their host."[27]

Although he took a number of nude photographs, only four have come to light. Other nude studies of children are occasionally attributed to Carroll's camera, but they are clearly not his work, mainly because they are photographic failures, and he diligently discarded failures. Before he died, furthermore, he destroyed most of the negatives and prints of his nude studies. Those that remained he asked his executors to destroy, and they apparently complied. Those that survive are the ones he gave to the sitters and their parents.

Carroll was perfectly aware of the social risks involved in taking photographs of children in the nude and extremely cautious about showing and giving copies of them. To one mother he wrote: ". . . would [you] like to have any more copies of the full-front . . . of the children. I have 2 or 3 prints of each, but I intend to destroy all but one of each. That is all I want for myself, and (though I consider them perfectly innocent in themselves) there is really *no* friend to whom I should wish to give photographs which so entirely defy conventional rules. . . . The negatives are already destroyed."[28]

Some critics refuse to take Carroll at face value. They pry into his mind intent upon finding impure motives, but these are largely of their own invention. They see a dour, bleak, unhealthy world in these photographs, a repressed sexuality writ large. One wonders if

they are not bringing their own neuroses to these works, twisting and despoiling their beauty. True, these children fired his genius and inspired his art; they paved the way to his great success in creating literary classics and capturing the innocence and beauty of childhood. Carroll was as successful in sublimating his emotional desires as he was in achieving his distinction as a photographic artist, and, certainly, the two are related. But he was aware of himself and his unconventional desires, and he was honest and open with his child sitters and with their elders. The demands he himself made upon his own conduct insured unblemished relationships. His photographs of children, even his nude studies, convey an innocence, an emotional purity char-

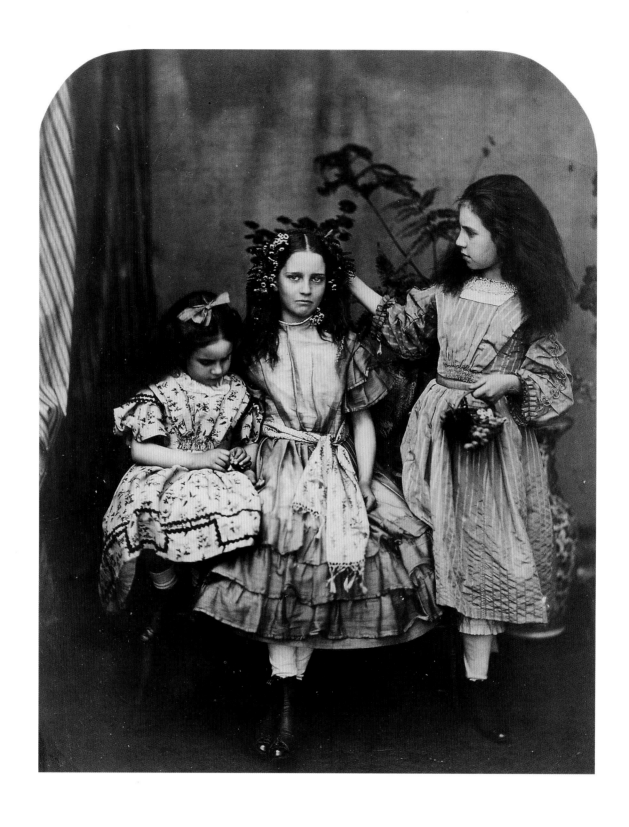

*Irene MacDonald, Flo Rankin, and Mary MacDonald in party dresses. Mary Josephine (1853–78) was "a dark-haired, sprightly little girl." Carroll probably took this photograph at the MacDonalds' home on July 31, 1863, when he wrote in his diary: "I have now done all the MacDonalds . . . and three children whom they brought in, Flora and Mary Rankin [among them]. . . ."*

acteristic of childhood. Critics who bring their own uneasiness to these photographs do the man and his talent an injustice.

"Would Charles Dodgson be hailed as a photographic celebrity had he not been Lewis Carroll?" asks Roy Aspin. "Almost certainly," he replies. "His portraits show a fertile imagination ahead of his time. In the international 'Family of Man' exhibition of 1956, Dodgson was one of the three British photographers represented, the other two being alive and using modern equipment."[29] Dodgson's place in the history of photography is now well established; it rests on the artistic quality of the photographs reproduced here and upon others like them.

"Considering . . . Carroll's many other activities," wrote the historian of photography Helmut Gernsheim, "his photographic achievements are truly astonishing: he must not only rank as a pioneer of British amateur photography, but I would also unhesitatingly acclaim him as the most outstanding photographer of children in the nineteenth century."[30] Edmund Wilson sees Carroll as "an important pioneer photographer . . . , a perfectionist," and, he continues, "in the posing, the arrangement of background, and the instinct for facial expression . . . [Carroll's photographs] show a strong sense of personality." He finds "a liveliness and humor in these pictures that sometimes suggest Max Beerbohm" and says that they anticipate Beerbohm's volume of drawings *Rossetti and His Circle*. "As for the pictures of children," Wilson continues, "they, too, are extremely varied and provide a . . . revelation of Lewis Carroll's special genius for depicting little English girls that is as brilliant in its way as *Alice*."[31]

Brassaï concurs with Gernsheim: "Indeed this pioneer of English amateur photography is the most remarkable photographer of children in the nineteenth century."[32] Graham Ovenden calls Carroll "a master" and claims that his achievement "lay in his ability to make concrete that which is transitory. . . . His children see further

than the page of the carefully positioned book and their serious observation reminds us poignantly of what we once were: the receptacles of unprejudiced knowledge, innocents abroad in a wonderland of experience."[33]

The trouble with much of what is written about Carroll is that it is too serious, given his brilliant whimsy. It was one of his great gifts, this ability to laugh and to make others laugh. Five months before he died, his artist friend Gertrude Thomson tried to entice him down to the seashore to sketch some nude children she had seen running about the sands. Carroll, in his reply concludes that it would be a

> . . . hopeless quest to try to make friends with any of the little nudities. . . . A *lady* might do it: but what would they think of a *gentleman* daring to address them! And then what an embarrassing thing it would be to *begin* an acquaintance with a naked little girl! What *could* one say to start the conversation? Perhaps a poetic quotation would be best. "And ye shall walk in silk attire." But would *that do*? . . . Or one *might* begin with Keats' charming lines, "Oh where are you going, with your lovelocks flowing, And what have you got in your basket?" . . . Or a quotation from Cowper (slightly altered) might do. *His* lines are "The tear, that is wiped with a little address, May be followed perhaps by a smile." But *I* should have to quote it as "The Tear, that is wiped with so little a dress"![34]

Lewis Carroll was exceptionally good at understanding himself, and perhaps that is why it is best to let him tell us about his attitudes toward art, photography, child friends, and nude models. His own words will live after most commentaries, including this one, have been long forgot.

He died of pneumonia in his family's home a hundred years ago, on January 14, 1898, and was buried in Guildford, Surrey.

# HIAWATHA'S PHOTOGRAPHING

*Lewis Carroll*

This parody of Longfellow's "The Song of Hiawatha" first appeared in a magazine called *The Train* in December 1857, some eighteen months after Carroll took up photography. He published three versions, all of which differed in several– mostly minor–respects. That printed here is the final one, published in *Rhyme? and Reason?* in 1883.

From his shoulder Hiawatha
Took the camera of rosewood,
Made of sliding, folding rosewood;
Neatly put it all together.
In its case it lay compactly,
Folded into nearly nothing;
But he opened out the hinges,
Pushed and pulled the joints and hinges,
Till it looked all squares and oblongs,
Like a complicated figure
In the Second Book of Euclid.

    This he perched upon a tripod–
Crouched beneath its dusky cover–
Stretched his hand, enforcing silence–
Said, "Be motionless, I beg you!"
Mystic, awful was the process.

    All the family in order
Sat before him for their pictures:
Each in turn as he was taken,
Volunteered his own suggestions,
His ingenious suggestions.

    First the Governor, the Father:
He suggested velvet curtains

Looped about a massy pillar;
And the corner of a table,
Of a rosewood dining-table.
He would hold a scroll of something,
Hold it firmly in his left-hand;
He would keep his right-hand buried
(Like Napoleon) in his waistcoat;
He would contemplate the distance
With a look of pensive meaning,
As of ducks that die in tempests.

    Grand, heroic was the notion:
Yet the picture failed entirely:
Failed, because he moved a little,
Moved, because he couldn't help it.

    Next, his better half took courage;
She *would* have her picture taken.
She came dressed beyond description,
Dressed in jewels and in satin
Far too gorgeous for an empress.
Gracefully she sat down sideways,
With a simper scarcely human,
Holding in her hand a bouquet
Rather larger than a cabbage.
All the while that she was sitting,
Still the lady chattered, chattered,
Like a monkey in the forest.
"Am I sitting still?" she asked him.
"Is my face enough in profile?
Shall I hold the bouquet higher?
Will it come into the picture?"
And the picture failed completely.

    Next the Son, the Stunning-Cantab:
He suggested curves of beauty,
Curves pervading all his figure,
Which the eye might follow onward,

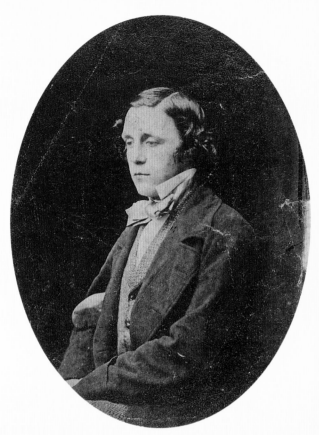

The earliest record of Dodgson being photographed occurs on January 10, 1855, when, at age twenty-three, he sat for a commercial photographer in Ripon while he was home for the Christmas vacation: "Got my likeness photographed by Booth. . . . After three failures he produced a tolerably good likeness, which half the family pronounced the best possible, and the other half the worst possible."

Till they centred in the breast-pin,
Centred in the golden breast-pin.
He had learnt it all from Ruskin
(Author of "The Stones of Venice,"
"Seven Lamps of Architecture,"
"Modern Painters," and some others);
And perhaps he had not fully
Understood his author's meaning;

*But, whatever was the reason,*
*All was fruitless, as the picture*
*Ended in an utter failure.*

*Next to him the eldest daughter:*
*She suggested very little,*
*Only asked if he would take her*
*With her looks of "passive beauty."*

*Her idea of passive beauty*
*Was a squinting of the left-eye,*
*Was a drooping of the right-eye,*
*Was a smile that went up sideways*
*To the corner of the nostrils.*

*Hiawatha, when she asked him,*
*Took no notice of the question*
*Looked as if he hadn't heard it;*
*But, when pointedly appealed to,*
*Smiled in his peculiar manner,*
*Coughed and said it "didn't matter,"*
*Bit his lip and changed the subject.*

*Nor in this was he mistaken,*
*As the picture failed completely.*

*So in turn the other sisters.*

*Last, the youngest son was taken:*
*Very rough and thick his hair was,*
*Very round and red his face was,*
*Very dusty was his jacket,*
*Very fidgety his manner.*
*And his overbearing sisters*
*Called him names he disapproved of:*
*Called him Johnny, "Daddy's Darling,"*
*Called him Jacky, "Scrubby School-boy."*
*And, so awful was the picture,*
*In comparison the others*
*Seemed, to one's bewildered fancy*
*To have partially succeeded.*

*Finally my Hiawatha*
*Tumbled all the tribe together,*
*("Grouped" is not the right expression),*
*And, as happy chance would have it*

*Did at last obtain a picture*
*Where the faces all succeeded:*
*Each came out a perfect likeness.*

*Then they joined and all abused it,*
*Unrestrainedly abused it,*
*As the worst and ugliest picture*
*They could possibly have dreamed of*
*"Giving one such strange expressions—*
*Sullen, stupid, pert expressions.*
*Really anyone would take us*
*(Anyone that did not know us)*
*For the most unpleasant people!"*
*(Hiawatha seemed to think so,*
*Seemed to think it not unlikely.)*
*All together rang their voices,*
*Angry, loud, discordant voices,*
*As of dogs that howl in concert,*
*As of cats that wail in chorus.*

*But my Hiawatha's patience,*
*His politeness and his patience,*
*Unaccountably had vanished,*
*And he left that happy party,*
*Neither did he leave them slowly,*
*With the calm deliberation,*
*The intense deliberation*
*Of a photographic artist:*
*But he left them in a hurry,*
*Left them in a mighty hurry,*
*Stating that he would not stand it,*
*Stating in emphatic language*
*What he'd be before he'd stand it.*
*Hurriedly he packed his boxes:*
*Hurriedly the porter trundled*
*On a barrow all his boxes:*
*Hurriedly he took his ticket:*
*Hurriedly the train received him:*
*Thus departed Hiawatha.*

The major difference between this version and the two earlier ones is the omission of eighteen lines describing the hazards of wet collodion photography. This had been generally superseded by dry plate photography in 1880 and so these lines were no longer appropriate in 1883. They are printed below.

*First, a piece of glass he coated*
*With collodion, and plunged it*
*In a bath of lunar caustic*
*Carefully dissolved in water—*
*There he left it certain minutes.*

*Secondly, my Hiawatha*
*Made with cunning hand a mixture*
*Of the acid pyro-gallic,*
*And of glacial-acetic,*
*And of alcohol and water—*
*This developed all the picture.*

*Finally, he fixed each picture*
*With a saturate solution*
*Which was made of hyposulphite,*
*Which, again, was made of soda.*
*(Very difficult the name is*
*For a metre like the present*
*But periphrasis has done it.)*

# KITH AND KIN

Although Lewis Carroll's birthplace, Daresbury Parsonage, Cheshire, was destroyed by fire in 1884, the site is now a shrine, a small outdoor museum tended by the Lewis Carroll Birthplace Trust, and is open to the public without charge. When Carroll was eleven, the Dodgson family moved into the Old Rectory, a three-storied Georgian edifice by the River Tees in Croft, Yorkshire. When Carroll's father died in 1868, the family moved south to "The Chestnuts" in Guildford, Surrey. Both of these residences are now in private hands.

Lewis Carroll became interested in photography when his maternal uncle Skeffington Lutwidge came to Croft and photographed the family. During the Easter vacation of 1856, Carroll, in London, purchased his rosewood box camera and lens, and started photographing in Oxford. When he returned to Croft for the summer vacation, he went with his equipment and began to photograph his family and friends in the north.

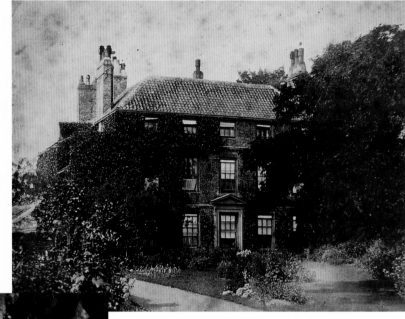

*Croft Rectory and garden, ca. 1857.*

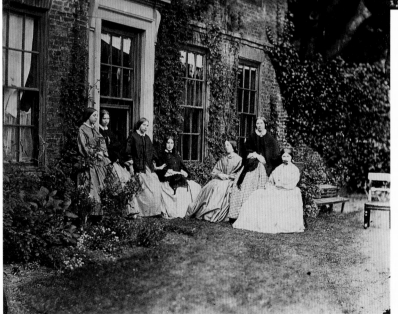

*Lewis Carroll's seven sisters in the Old Rectory garden, Croft, ca. 1857.*

*Lewis Carroll's youngest brother, Edwin, with brother Wilfred's dog, photographed in July 1857.*

*I am sitting alone in my bedroom this last night of the old year, waiting for midnight. It has been the most eventful year of my life: I began it a poor bachelor student, with no definite plans or expectations; I end it a master and tutor in Christ Church, with an income of more than £300 a year, and the course of mathematical tuition marked out by God's providence for at least some years to come. Great mercies, great failings, time lost, talents misapplied—such has been the past year.*

—LEWIS CARROLL, *December 31, 1855*

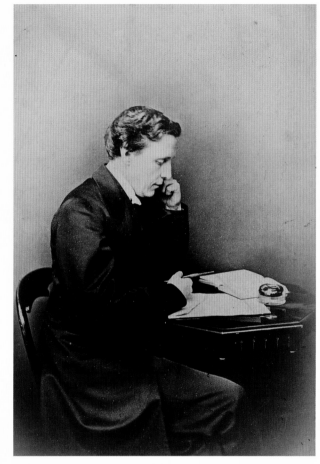

*Lewis Carroll, perhaps a self-portrait.*

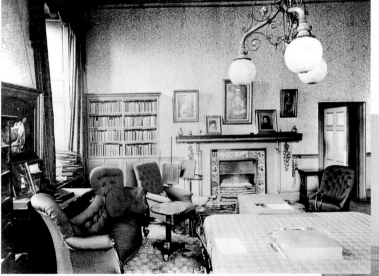

Right: *Tom Quad, Christ Church.*
Above: *Lewis Carroll's sitting room at Christ Church, by an unidentified photographer.*

# THE DODGSON HOME AND FAMILY

*Lewis Carroll's seven sisters in the Old Rectory garden, Croft.*

*Carroll's father, Archdeacon Charles Dodgson (1800–1868) earned a Double First in Classics and Mathematics at Christ Church, Oxford, married his first cousin Frances Jane Lutwidge, and became, while Rector of Croft, Archdeacon of Richmond and Canon of Ripon. Taken in Yorkshire, May 1860.*

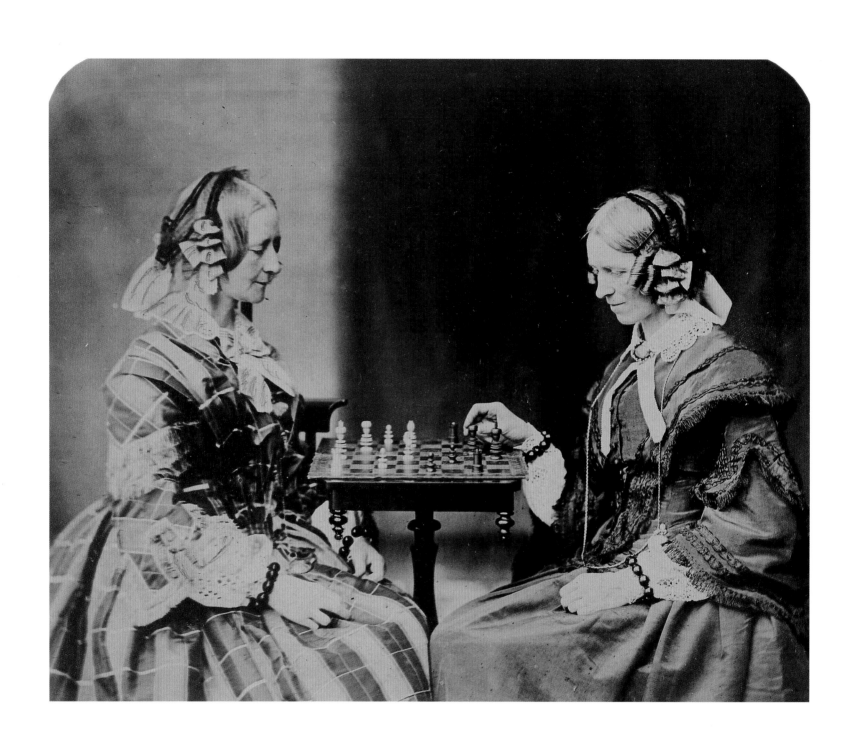

*Two Lutwidge sisters, Margaret Anne and Henrietta May, Lewis Carroll's maternal aunts, ca. 1859. ·*

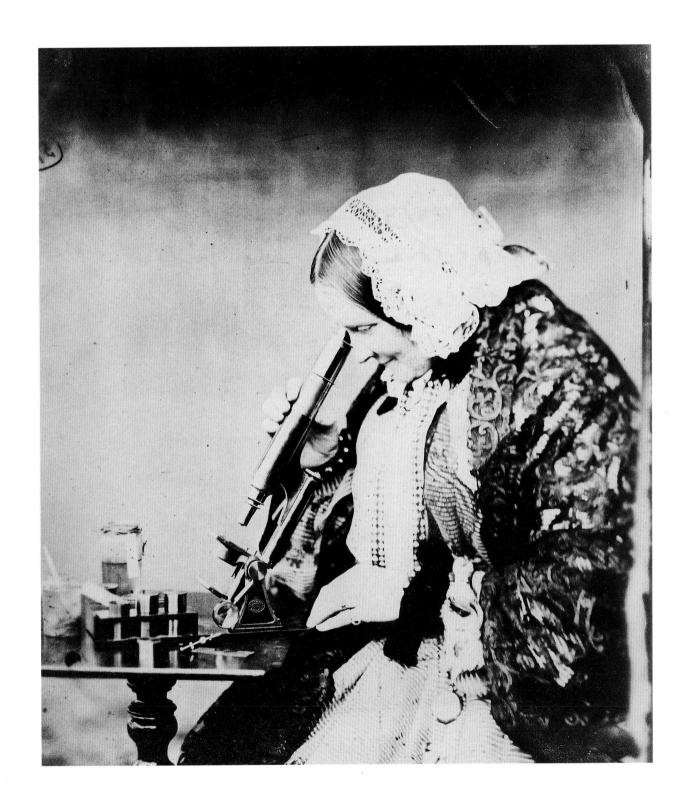

*When Carroll's mother died in 1851, her sister Lucy Lutwidge (1805–1880) took over the management of the home. Carroll used all manner of props in photographs, which not only made for more interesting results, but, in giving the sitters something to hold or something to focus on, helped them to relax. This photograph was taken in 1859.*

*In August 1856 and September 1857, Lewis Carroll traveled with his photographic equipment in the north of England and Scotland; on both journeys he visited his great-uncle Henry Thomas Lutwidge (1780-1861), Commander, Royal Navy, at Ambleside in the Lake District, whose home he photographed.*

*Lewis Carroll's brother Skeffington Hume Dodgson (1836–1919) was the second Dodgson son. Carroll photographed him in the Lake District in August 1856.*

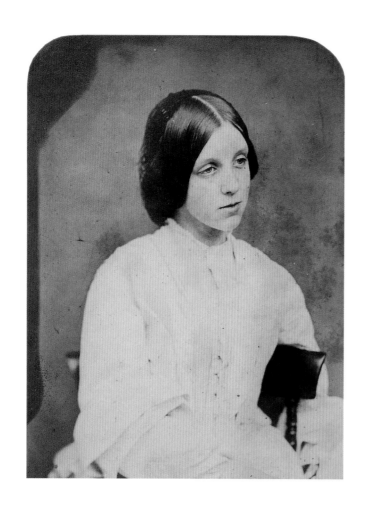

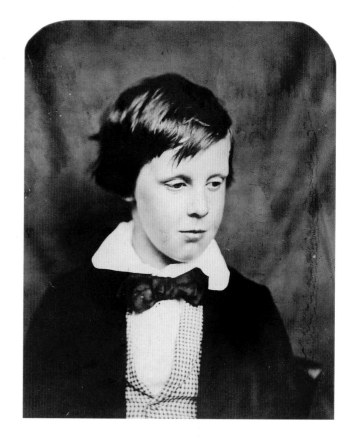

*Henrietta Harington Dodgson (1843–1922),*
*the youngest Dodgson daughter, taken ca. 1857.*

*The youngest Dodgson child, Edwin Heron (1846–1918) never*
*married, took holy orders, and became a missionary on Tristan*
*da Cunha in the South Atlantic, where he has been honored*
*with a commemorative issue of postage stamps. Taken ca. 1857.*

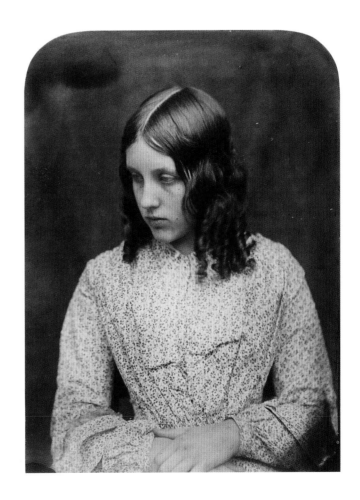

*The seventh of the eleven Dodgson children, the third of the four sons, Wilfred Longley Dodgson (1838–1914) took a B.A. at Christ Church, married, and became Agent of Lord Boyne's estate in Shropshire. Taken ca. 1857.*

*Margaret Anne Ashley Dodgson (1841–1915) was the sixth Dodgson daughter. This portrait is ca. 1857.*

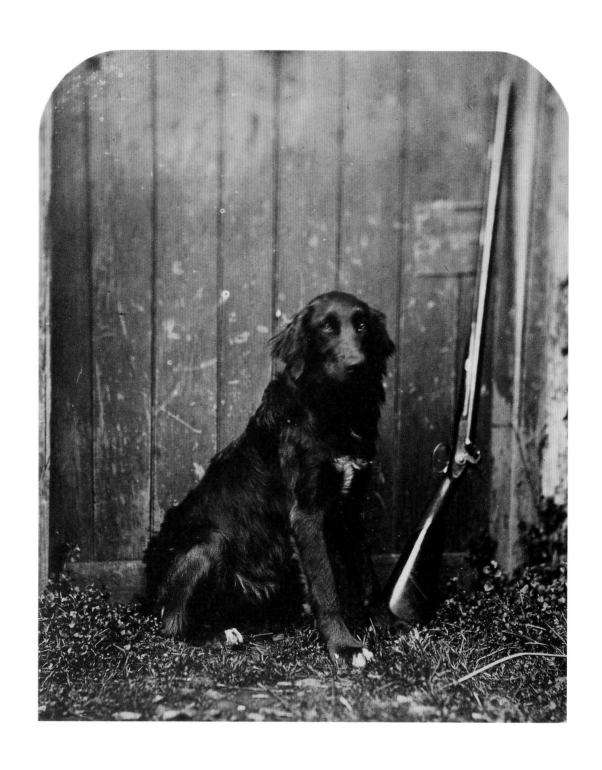

*Dido, Wilfred Dodgson's dog, 1857.*

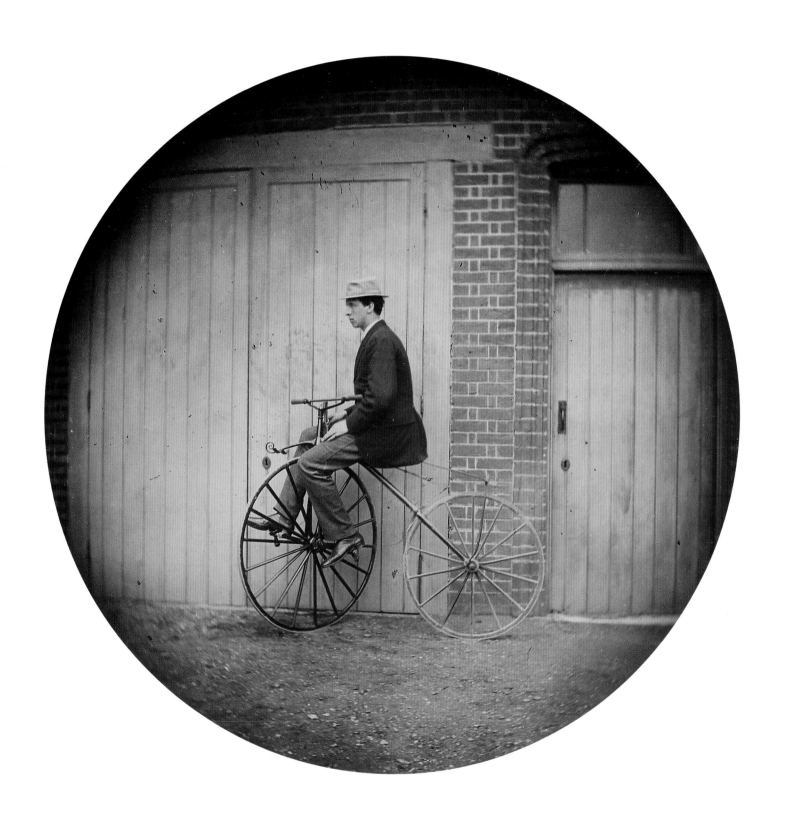

*Wilfred Dodgson was fond of sports, including boxing. His dog, his rifle, and his early-
style "Boneshaker Velocipede" bicycle made good photographic subjects for his elder brother.
This portrait was made in front of the stables at "The Chestnuts" during October 1869.*

*The Wilcoxes were cousins of the Dodgsons and lived in nearby Whitburn on the North Sea; the two families frequently visited each other. When together they played games, acted out charades, and staged various competitions. It was at the Wilcoxes' that Lewis Carroll conceived of the earliest version of "Jabberwocky." Henry George Wilcox (1839–1907), third son, Captain of the "St. Lawrence," which sailed between England and Calcutta, also commanded the "Glenfinlas," which sailed to China and back. Here he is pre-beard (1856) and, on the right, bearded.*

*Henry George Wilcox, July 7, 1866.*

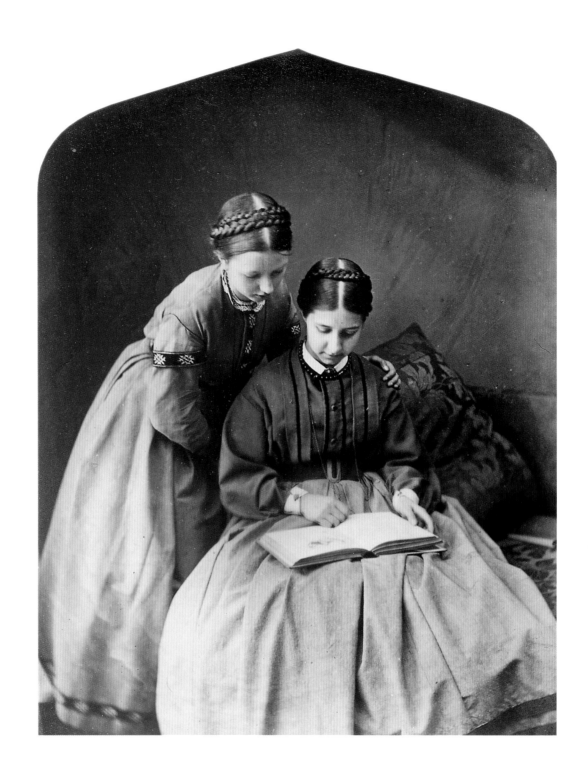

*Alice Jane Donkin (1851–1929) married Lewis Carroll's brother Wilfred in 1871. Alice Emily Donkin, Alice Jane Donkin's cousin, was the daughter of William Fishburn Donkin, Professor of Astronomy at Oxford. Carroll took this photograph of the two Alice Donkins on May 14, 1866.*

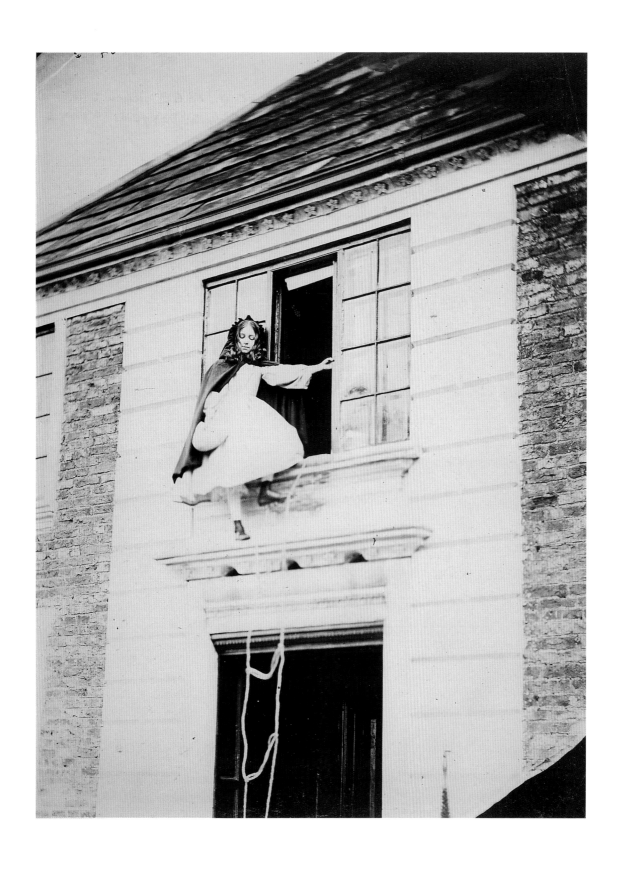

*Wilfred Dodgson and Alice Donkin did not elope, but brother Lewis Carroll staged this "Elopement" for his camera on October 9, 1862.*
*Alice Donkin descends by rope ladder from her bedroom window for his camera. Alice and Wilfred were married in the summer of 1871.*

# FRIENDS AND COLLEAGUES

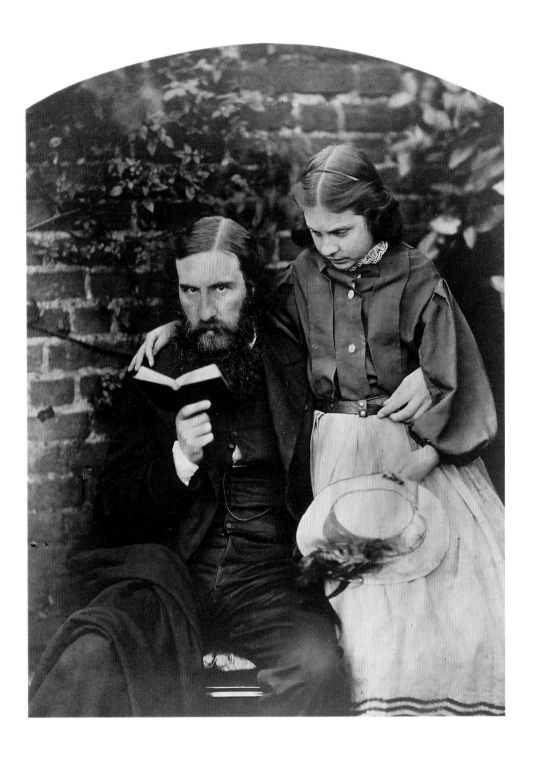

*Both Lewis Carroll and the novelist George MacDonald (1824–1905) stammered. They met at the home of their speech therapist. Carroll and MacDonald found they also shared religious views and literary tastes. Carroll and the large MacDonald family soon became fast friends. Carroll here photographed MacDonald with his eldest daughter Lilia "Lily" Scott MacDonald (1852–1891) at their home in Kensington on October 14, 1863.*

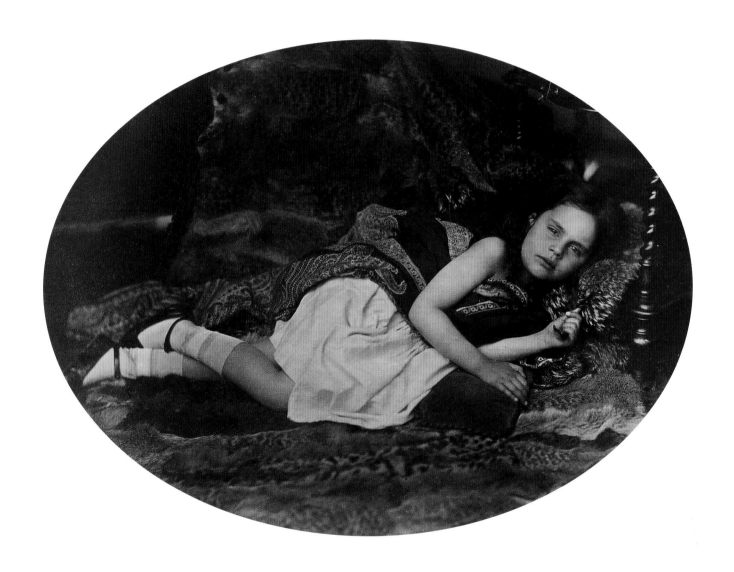

IRENE MAC DONALD

*Irene (b. 1857), the MacDonalds' fourth daughter, 1863.*

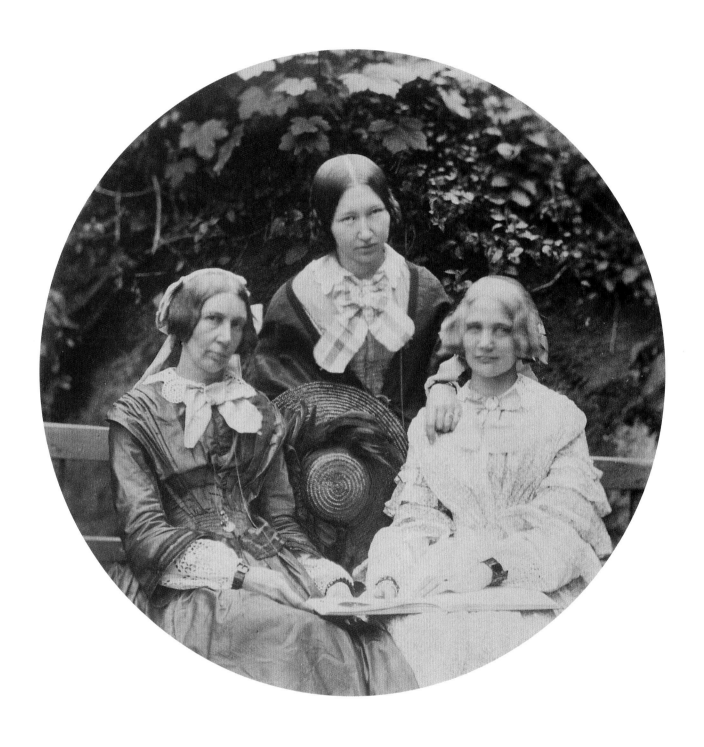

*In August 1856, Carroll, in the Lake District with his brother Skeffington and his camera, called on Mrs. Favell and then spent an evening with the Favell family, apparently old acquaintances. He very likely took this photograph of Mrs. Favell and two daughters then.*

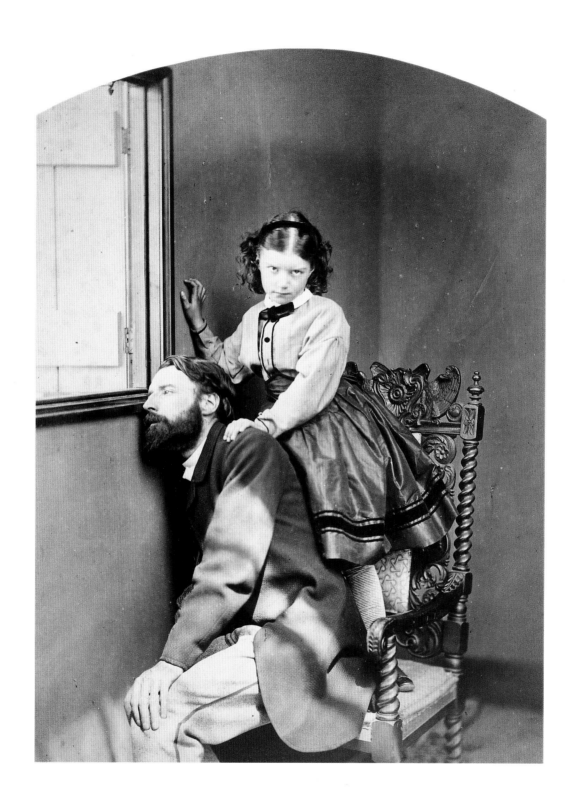

*[Rev. Thomas Childe] "Barker arrived with his eldest child, May, whom I had begged he would bring over to be photographed," Carroll wrote in his diary on June 6, 1864. "Took three pictures of her [at Christ Church]. One, with him, looks first rate."*

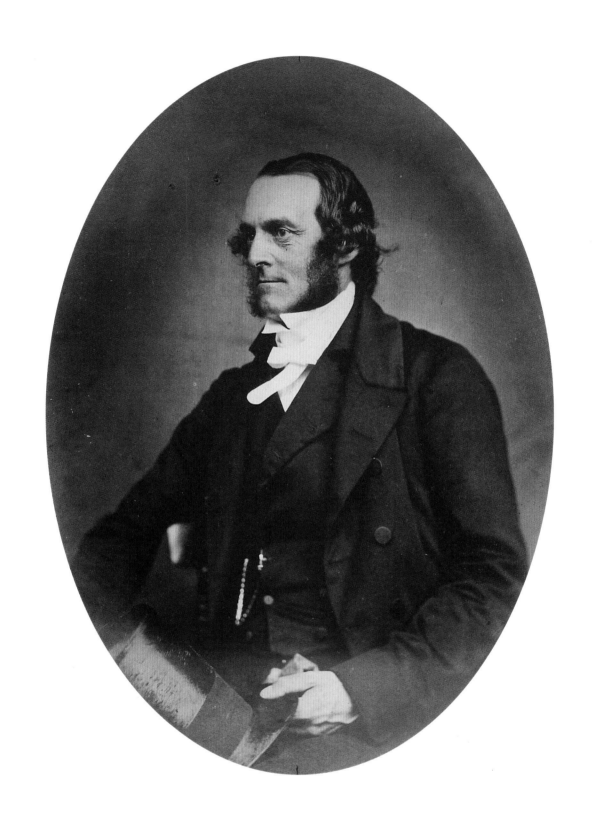

*Rev. John William Smith (1811–1897), Rector of Dinsdale, Darlington,*
*from 1851 to 1859. Carroll photographed him on August 4, 1857,*
*at Dinsdale Rectory, not far from the Dodgson family home at Croft.*

*During the summer vacation of 1855, Carroll, home at Croft, helped to teach in the local school that was his father's pride and joy. On July 9, he took "the first class alone in Old Testament (part of Judges). Mr. Hobson wants some assistance in Latin. . . ." Henry Hobson and his wife Sarah Gordon Hobson both taught in the school. Here they are with their children, photographed at Croft Rectory in August 1857.*

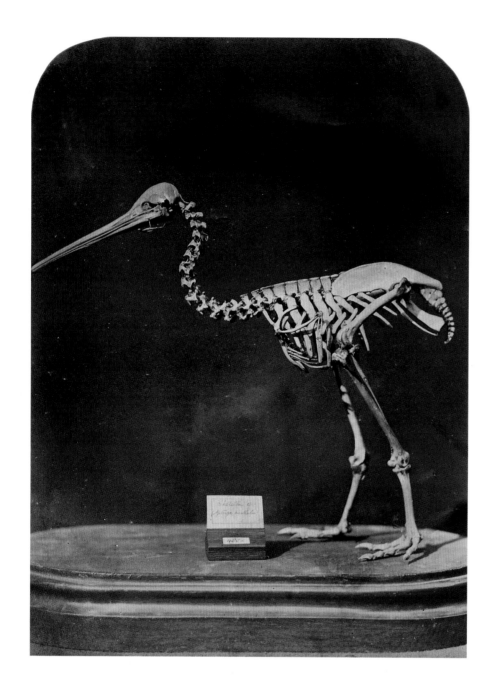

You are bones, and what of that?
Every face, however full,
Padded round with flesh and fat,
Is but modell'd on a skull.

—LEWIS CARROLL

*Not a person but a beast: "Museum exhibit—bird skeleton" (an* Apterix australis, *or emu, from the Christ Church Anatomy Museum), 1857.*

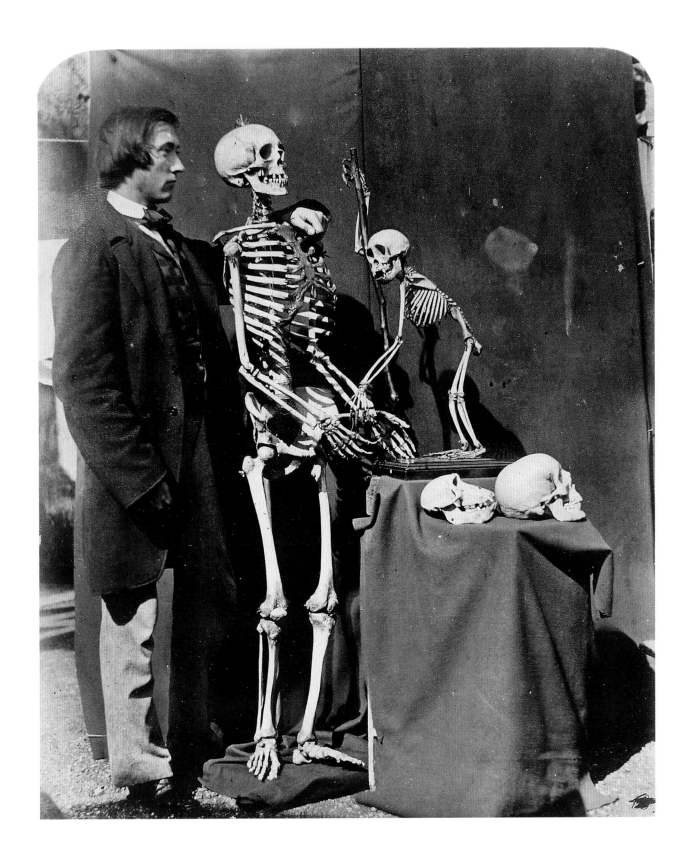

*Reginald Southey (1835–1899), a Christ Church undergraduate studying medicine, was an amateur photographer who encouraged Carroll to take up the art. A year before Carroll bought his camera, he was already admiring Southey's work. The skeletons of a human and an ape fall in line with Southey's medical studies. The photograph, taken in 1857, predates the controversy engendered by the publication of Darwin's* On the Origin of Species by Natural Selection *by two years.*

*Thomas Combe (1797–1872), left, printer, Director of Oxford University Press, 1860.*

*Carroll must have become acquainted with Edward Wright Whitaker (1840–1881), right, at Oxford when Whitaker was an undergraduate there. When the Curacy at Croft fell vacant in 1864, Carroll's father, the Rector of Croft, was searching for a replacement. "Wrote to Whitaker," Carroll noted in his diary, "by my father's desire, inviting him to Ripon. . . . I am very hopeful that it will end in his being engaged as curate. . . ." Whitaker was duly appointed. This photograph dates from September 1865.*

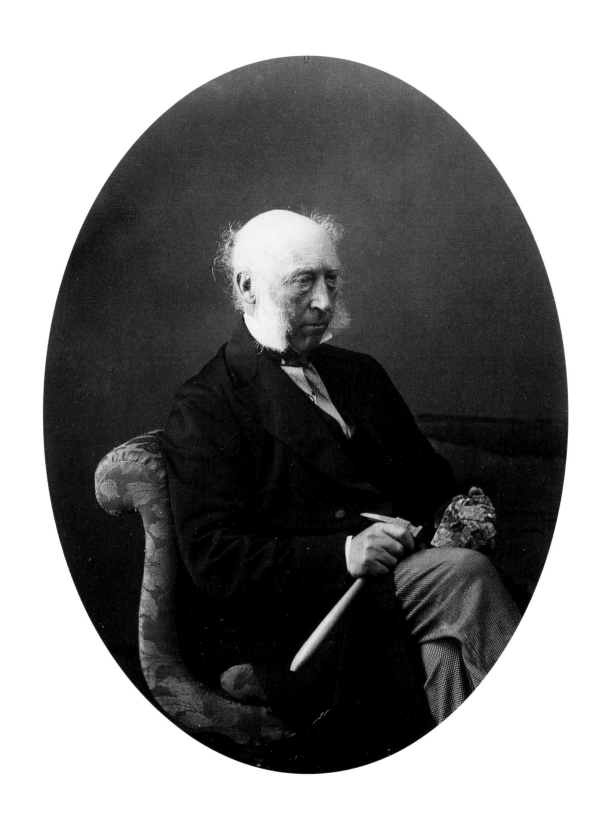

*John Phillips (1800–1874), geologist, Keeper of the Ashmolean Museum, Oxford (1854–1870), 1866.*

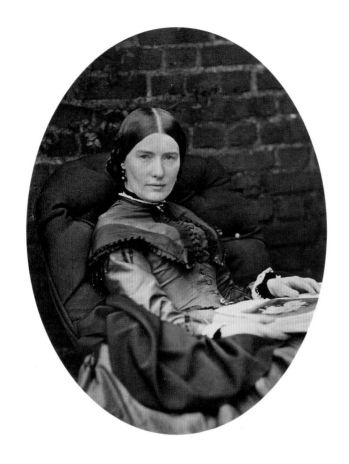

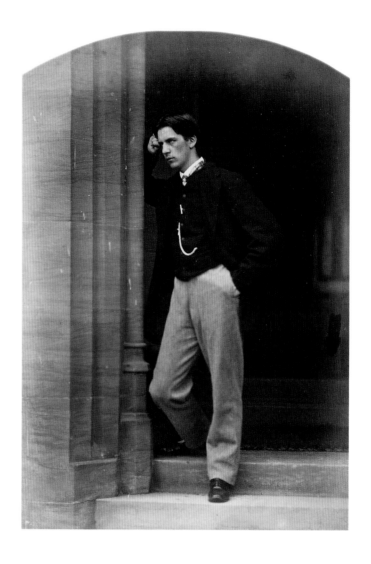

*Fanny Strong was the wife of Henry Linwood Strong (1816–1886) and daughter of Henry David Erskine (1786–1859), Dean of Ripon. Carroll photographed her on October 10, 1863.*

*Robert Bickersteth (1816–1884) succeeded Longley as Bishop of Ripon in 1857. "Dined at the [Bishop's] Palace [in Ripon]," Carroll wrote in his diary on January 14, 1858. "The [Bishop's] children all appeared in the course of the evening: I especially admire the eldest boy, Robin [Robert, Jr.]: his thoughtful and intellectual face makes him look some years older than he is."*

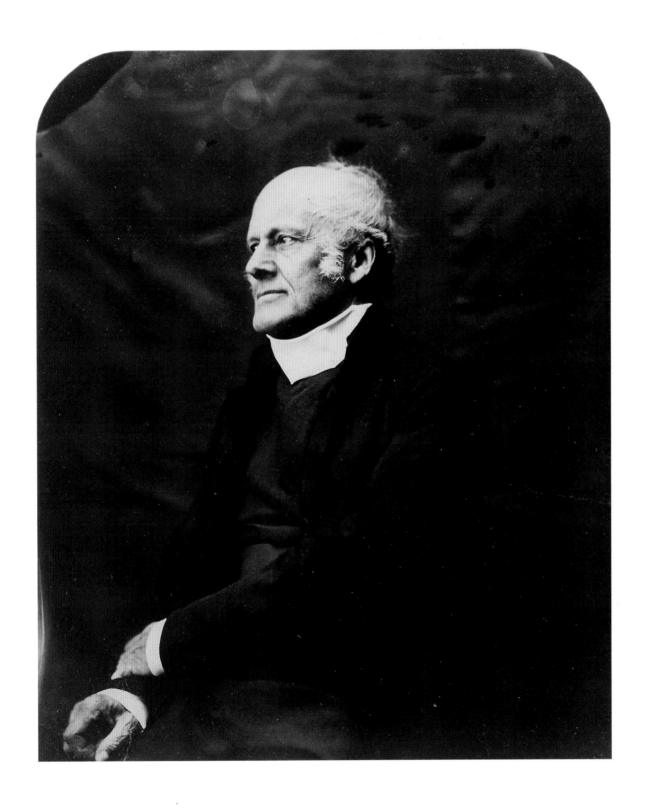

*Charles Thomas Longley (1794–1868) ca. 1859. Longley and his family were close friends of the Dodgsons. Carroll's father was examining chaplain to Longley when Longley was Bishop of Ripon, and the Dodgsons lived part of every year at The Residence in Ripon. When Longley became Archbishop of Canterbury, Carroll arranged to use Lambeth Palace, the Archbishop's London residence, as a photographic venue. Carroll photographed Longley frequently.*

# ANGELS FROM HEAVEN

**C**hildren had a special effect upon Charles Dodgson. They sparked his imagination and transformed him from a reserved Oxford mathematics don with a difficult name to an inspired storyteller whose pen name, Lewis Carroll, had a musical, liquid sound, easy to write and to remember. These young girls–for they were mostly the female of the species–not only changed his personality and provoked his creative faculties; they were mainstays of his life. He was drawn naturally to them; he revelled in their unaffected innocence and their unsophisticated, unsocialized simplicity. He worshipped their fresh, pure unspoiled beauty, he cherished their companionship, he showered them with gifts, he created stories, games, and puzzles for them, he took them on outings, and, of course, he photographed them.

*Lewis Carroll used looking-glasses in his photographs as well as in his written works. This is Julia Arnold. She married (1885) Leonard Huxley and was mother of Julian and Aldous Huxley.*

*Any one that has ever loved one true child will have known the awe that falls on one in the presence of a spirit fresh from God's hands, on whom no shadow of sin . . . has yet fallen.*

—LEWIS CARROLL

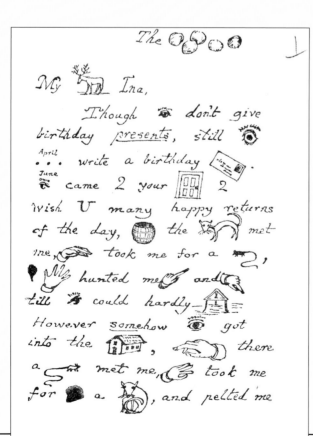

*The first page of Carroll's rebus letter to Georgina Watson.*

The friendship that grew up between Lewis Carroll and Alice Liddell was remarkable and defies description. They were attuned to one another in a deep spiritual bond, a fact evident in the photographs he took of her, for they are magical, revealing Carroll at his most inspired as a photographer and Alice responding with warmth and understanding. Together they created great works of art. Lorina "Ina" Charlotte (1849–1930), Alice Pleasance (1852–1934), and Edith Mary (1854–1876) were the children of Henry George Liddell (1811–1898), Dean of Christ Church and distinguished Greek scholar, and his wife, Lorina (1826?–1910).

*Below: "The Hidden Alice": Carroll first drew a picture of Alice Liddell at the end of the manuscript of* Alice's Adventures Under Ground, *now in the British Library. Then, dissatisfied with the result, he pasted over it a trimmed photograph he had taken of his ideal child friend.*

*This acrostic verse, in Carroll's own script, appears on the front inner cover of a copy of Catherine Sinclair's* Holiday House *that Carroll gave to the three Liddell sisters. On the fly-leaf, Carroll wrote: "L. A. and E. Liddell / a Christmas gift / from C. L. Dodgson."*

Little maidens, when you look
On this little story-book,
Reading with attentive eye
Its enticing history,
Never think that hours of play
Are your only **HOLIDAY**,
And that in a **HOUSE** of joy
Lessons serve but to annoy:
If in any **HOUSE** you find
Children of a gentle mind,
Each the others pleasing ever—
Each the others vexing never—
Daily work and pastime daily
In their order taking gaily —
Then be very sure that they
Have a *life* of **HOLIDAY**.

90

*of her own little sister. So the boat wound slowly along, beneath the bright summer-day, with its merry crew and its music of voices and laughter, till it passed round one of the many turnings of the stream, and she saw it no more.*

*Then she thought, (in a dream within the dream, as it were,) how this same little Alice would, in the after-time, be herself a grown woman: and how she would keep, through her riper years, the simple and loving heart of her childhood: and how she would gather around her other little children, and make* their *eyes bright and eager with many a wonderful tale, perhaps even with these very adventures of the little Alice of long-ago: and how she would feel with all their simple sorrows, and find a pleasure in all their simple joys, remembering her own child-life, and the happy summer-days. days.*

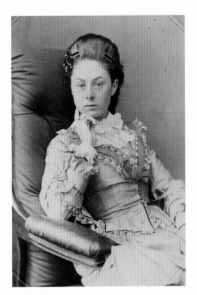

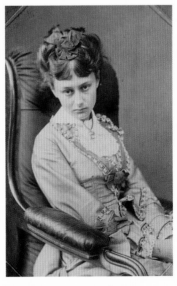

*Lorina (left) and Alice Liddell (right) as mature young women of twenty and eighteen, respectively. These are the last photographs that Carroll took of the Liddell sisters, long after the magic of their friendship had evaporated.*

# ALICE AND HER SISTERS

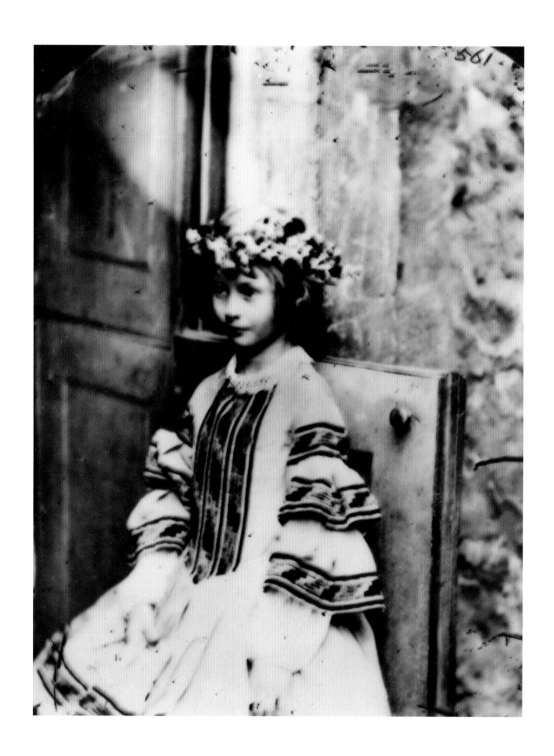

*Alice Liddell, wreathed, 1860.*

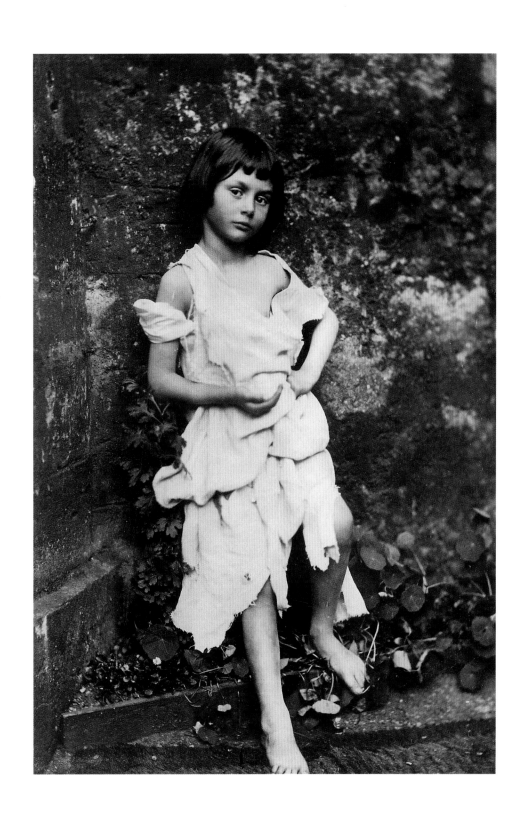

*Alice as a beggar girl, perhaps the most memorable photograph that Carroll ever took, ca. 1859.*

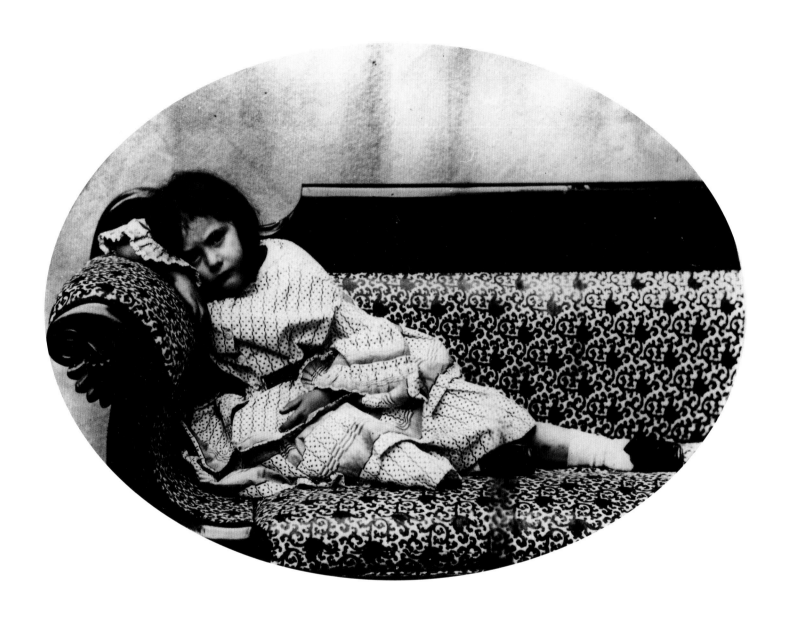

*Edith Liddell, apparently not very happy at having to hold a pose for almost a whole minute, 1860.*

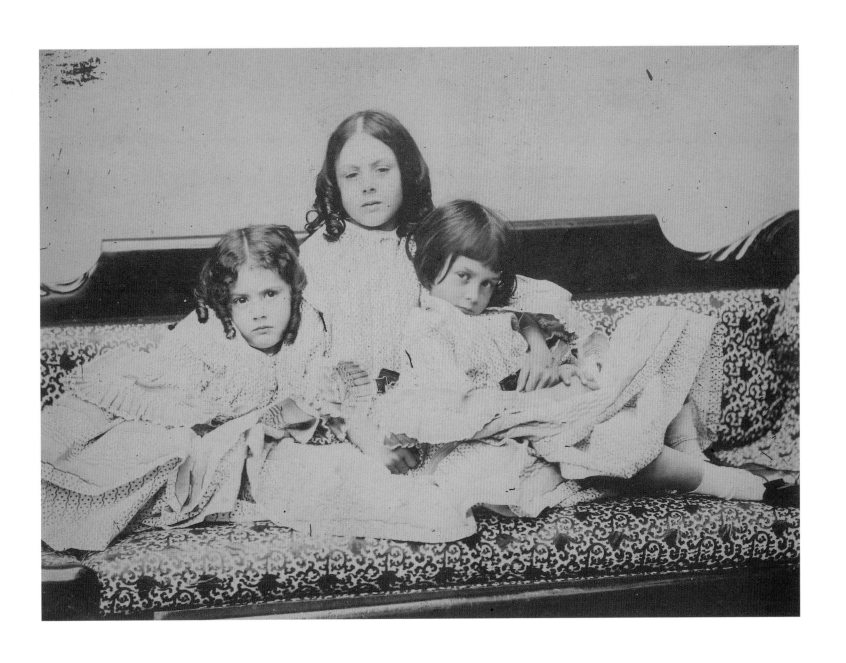

*The Liddell trio, taken very early, perhaps in 1858, when Alice (right) was six.*

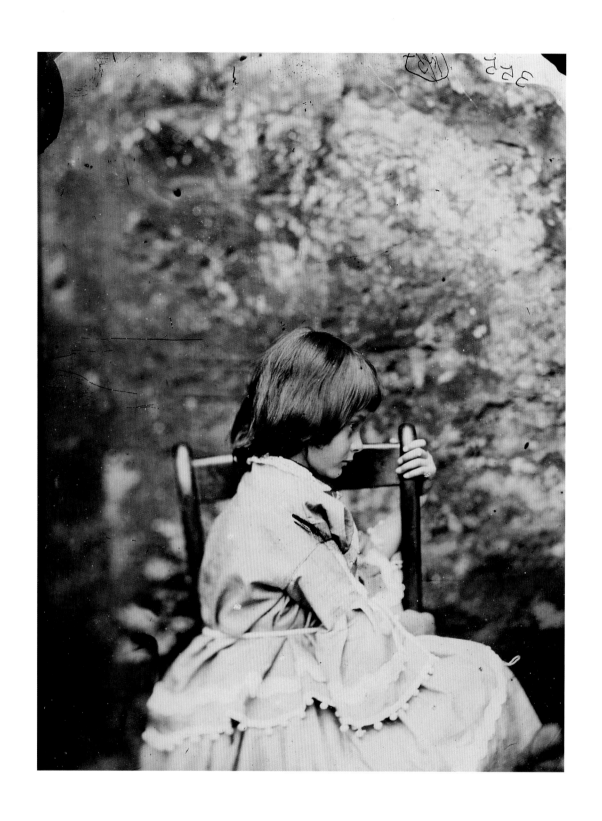

*Alice in one of Carroll's most successful portraits, 1858.*

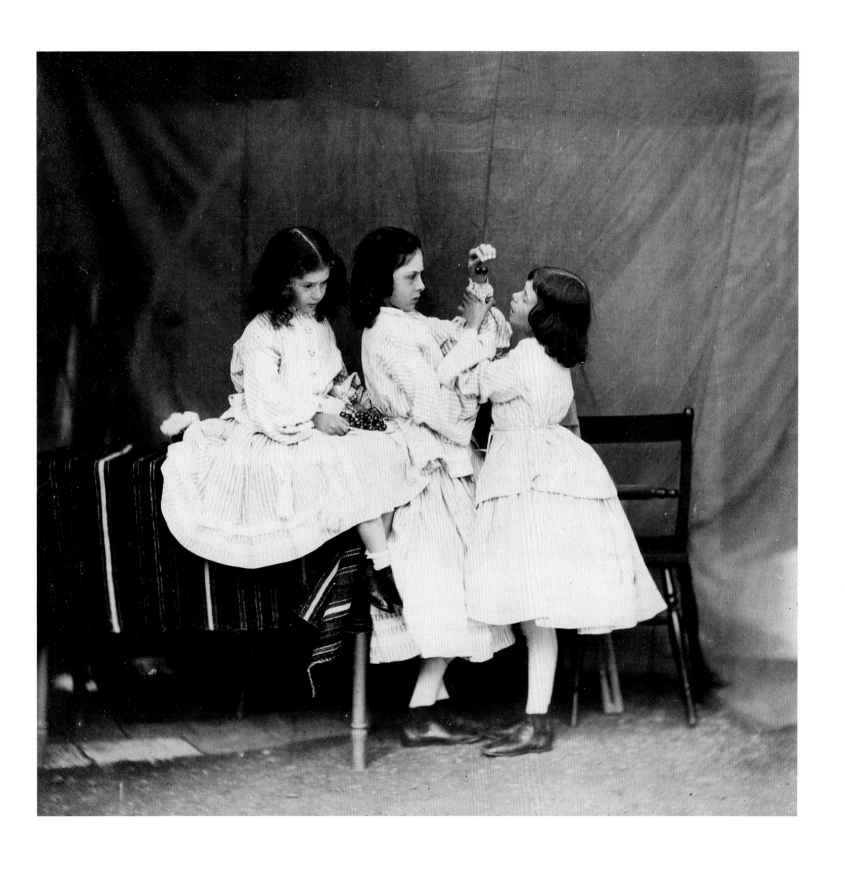

*The Cherry group: "Open your mouth and shut your eyes," with Edith, Lorina, and Alice Liddell, July 1860.*

# XIE KITCHIN

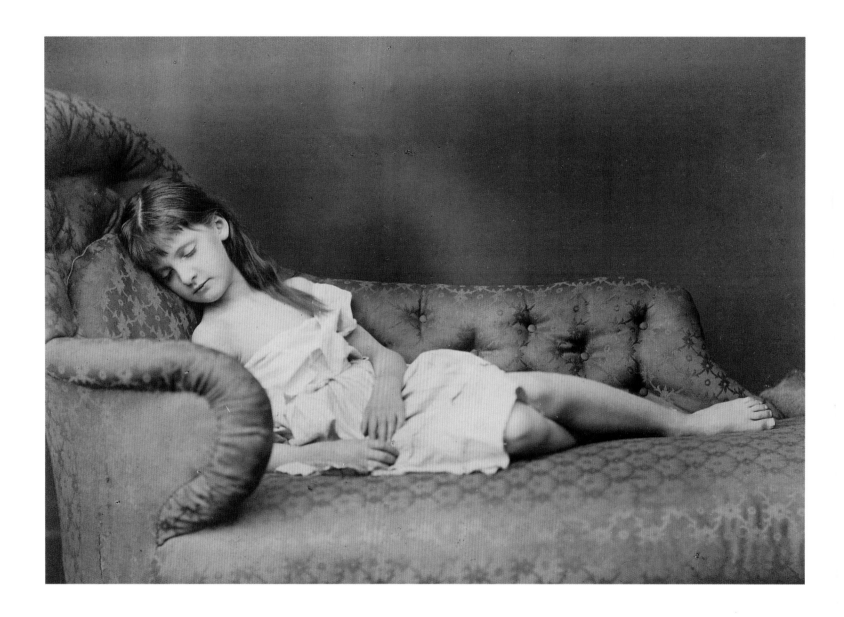

*Alexandra (Xie) Kitchin. George William Kitchin (1827–1912), biographer, historian, later Dean of Winchester and Durham, was a senior colleague of Carroll's at Christ Church when Carroll was appointed Mathematical Lecturer. Kitchin's daughter Alexandra Rhoda Kitchin (1864–1925), named after her godmother, Alexandra, Princess of Wales (later Queen of Great Britain) was an extraordinarily beautiful young girl who became one of his favorite models, and he photographed her in all manner of poses and foreign dress. Henry Holiday, who illustrated Carroll's* The Hunting of the Snark, *writes in his* Reminiscences of My Life *(1914): ". . . Dodgson asked me if I knew how to obtain excellence in a photograph. I gave it up. 'Take a lens and put Xie before it.'"*

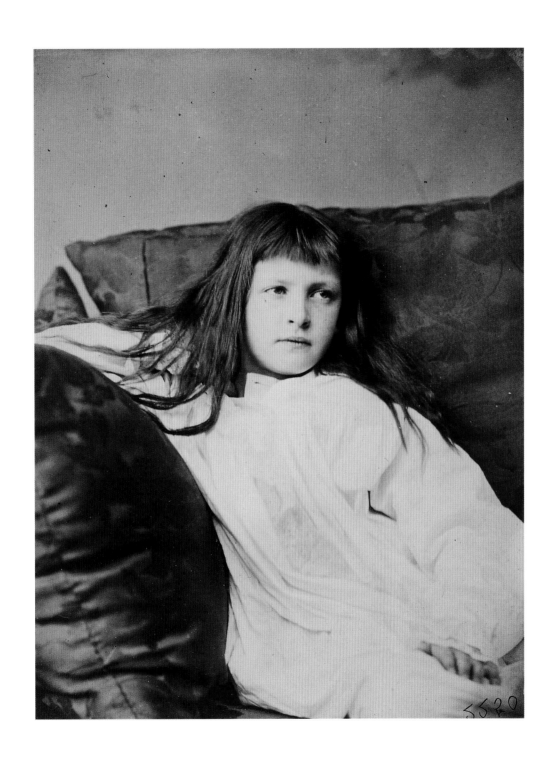

*"Sleepless," 1874.*

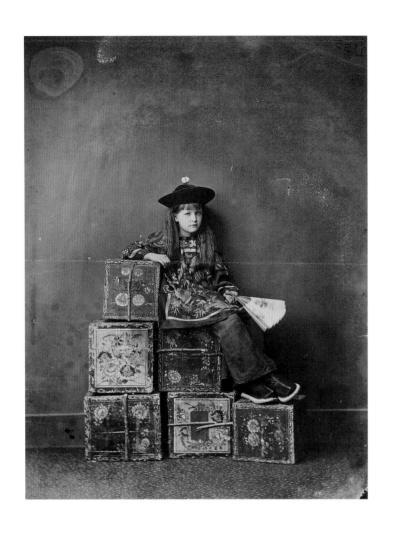

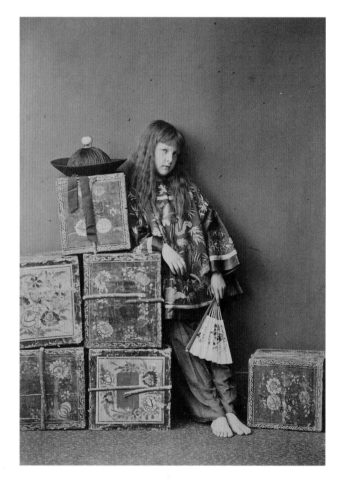

*"Took Xie in Chinese dress (2 positions)," Carroll wrote in his diary on July 14, 1873.*

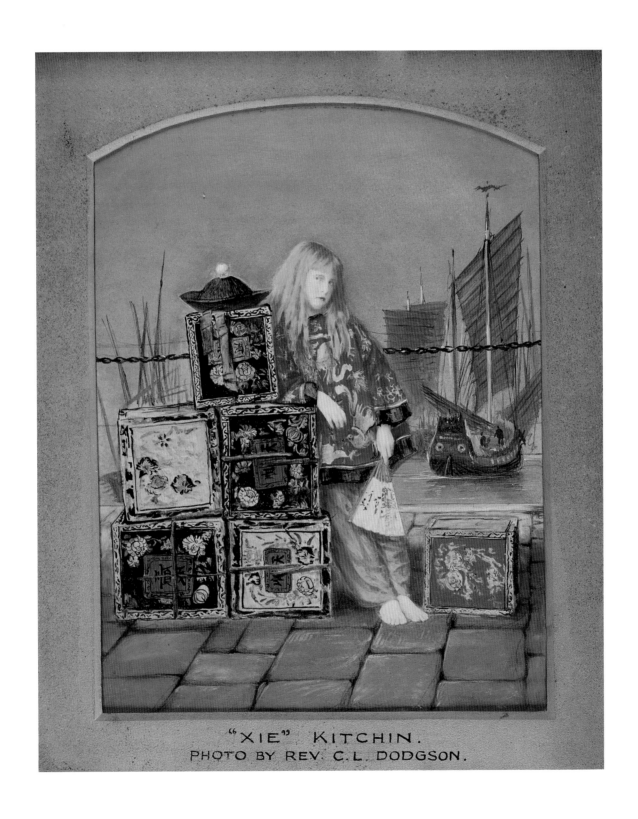

"XIE" KITCHIN.
PHOTO BY REV. C.L. DODGSON.

*Carroll thought one of the poses good enough to have hand-colored.*

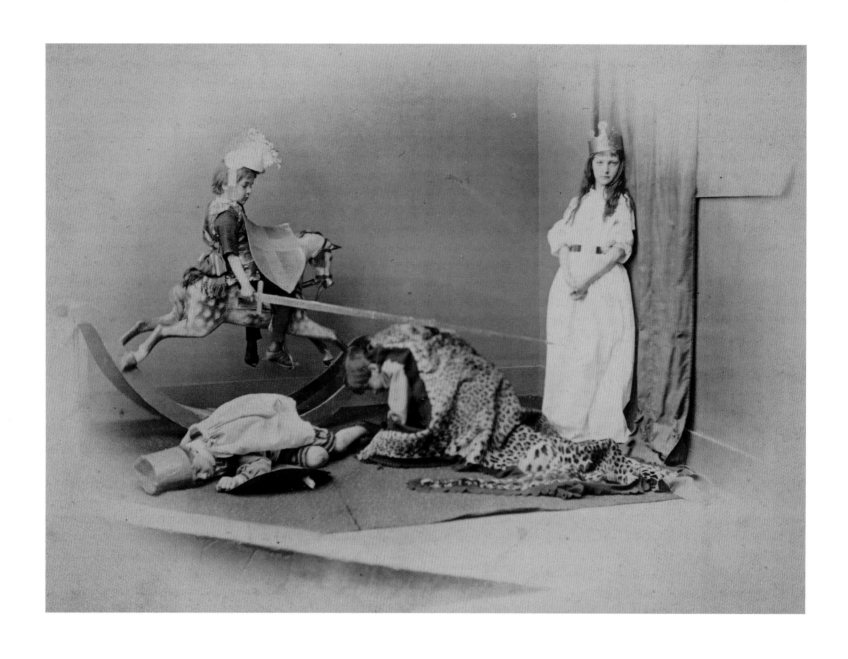

*Staged in Lewis Carroll's Christ Church rooms in June 1875, Xie and her three brothers compose the tableau "Saint George and the Dragon."*
*Her three brothers were George Herbert Kitchin (b. 1865), Hugh Bridges Kitchin (1867–1945), and Brook Taylor Kitchin (1869–1940).*

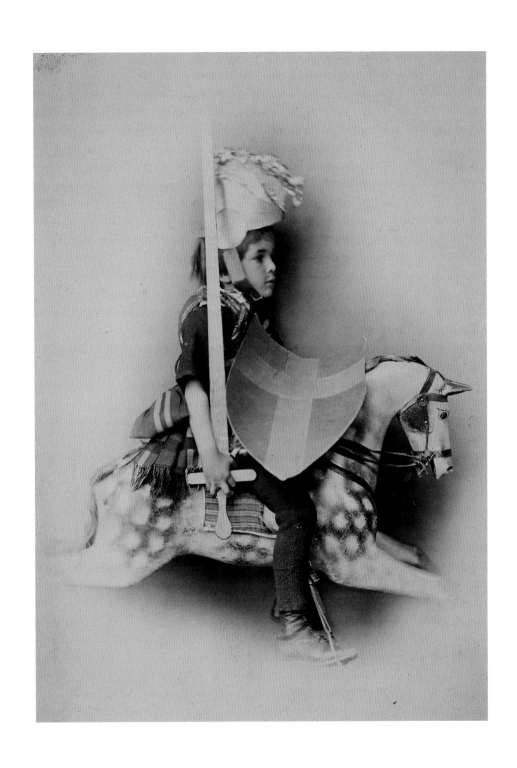

*Brook Kitchin as Saint George, 1875.*

*A Scandinavian Xie, 1873.*

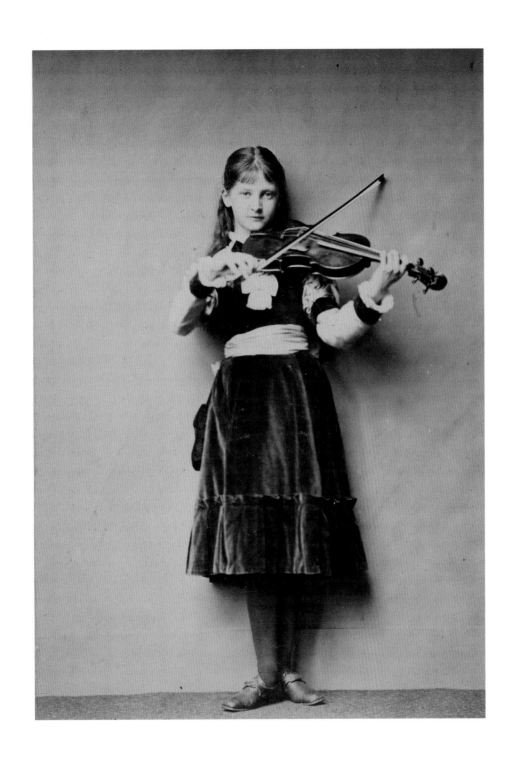

*Xie as a violinist, 1876. She braces herself for the long exposure by resting her bow against the wall.*

*"Mrs. Kitchin brought Xie to be photographed, and I got 4 good ones, two being as 'Penelope Boothby,'" Carroll wrote in his diary on July 1, 1876. Penelope Boothby (1785–1791) was the only child of Sir Brooke Boothby (1744–1824), 7th Baronet, a minor poet and member of the distinguished literary circle at Lichfield. Brooke mourns her death in a volume of verse,* Sorrows. Sacred to the Memory of Penelope *(1796). In May 1788 he had had her portrait engraved by Sir Joshua Reynolds, and the Reynolds portrait of this beautiful child became the paradigm for later artists to copy, notably for Samuel Cousins, whose engraving of Penelope became equally famous. Carroll had one of these engravings in mind when staging this photograph.*

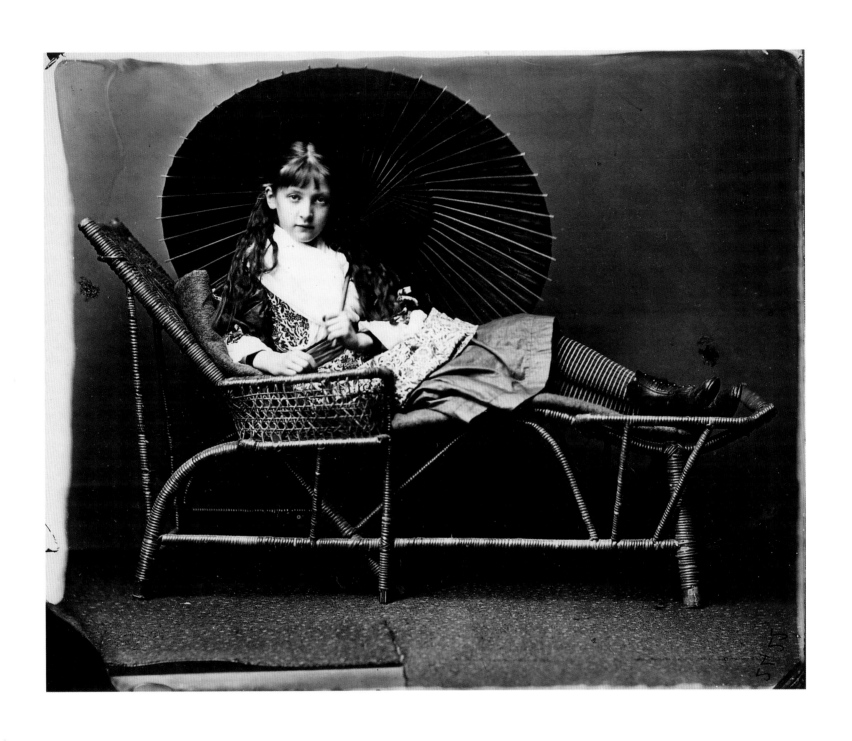

*Another remarkable pose of Xie, reclining with a parasol, also taken in 1876.*

# THE HATCH SISTERS

The Hatch sisters were another trio whom Carroll admired and photographed. He was a friend of the family for more than twenty-five years. The parents were Edwin Hatch (1835–1889), Vice-Principal of St. Mary's Hall, Oxford, and University Reader, and his wife, Bessie Cartwright Thomas Hatch (1839–1891). All three of the daughters were comfortable posing nude for Carroll. They were Beatrice Sheward Hatch (1866–1947), Ethel Charlotte Hatch (1869–1975), and Evelyn Maud Hatch (1871–1951). Carroll christened the trio BEE, the initial letters of their given names. Above left is Beatrice seated before white cliffs, a watercolor painted by Anne Lydia Bond in 1873, probably achieved by placing a translucent piece of paper over Carroll's print. Above right is Evelyn Hatch, 1879.

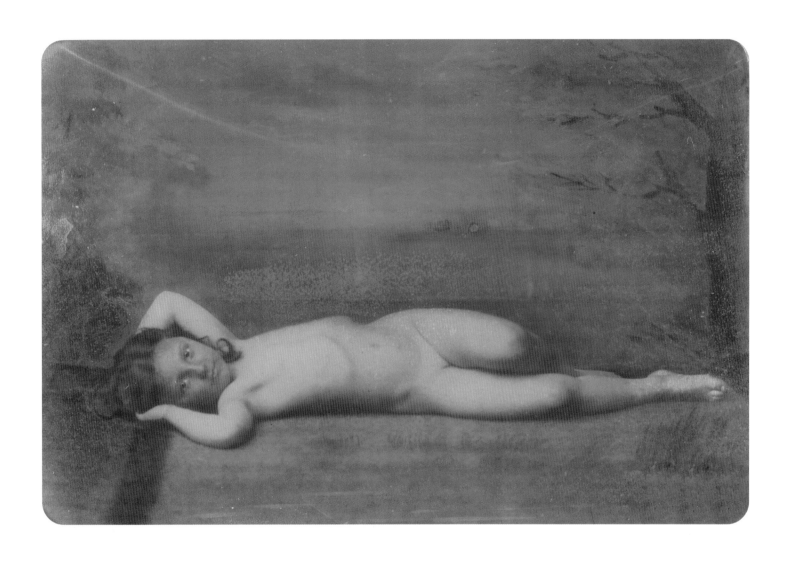

*Carroll took some of his favorite photographs to be hand-colored by various female amateur artists. Four of Carroll's nude studies survive, all hand-colored. Above is Evelyn Hatch, 1879.*

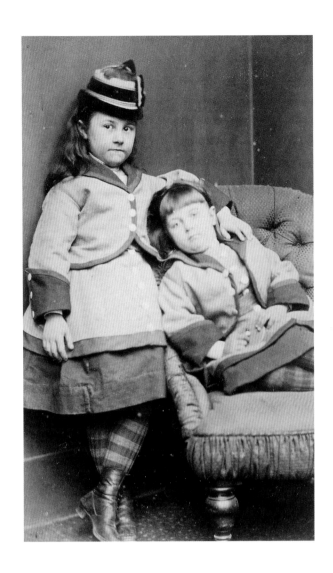

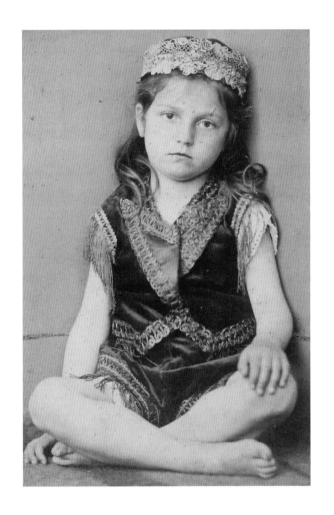

*Beatrice and Ethel Hatch, 1872.*

*Beatrice in fancy dress.*

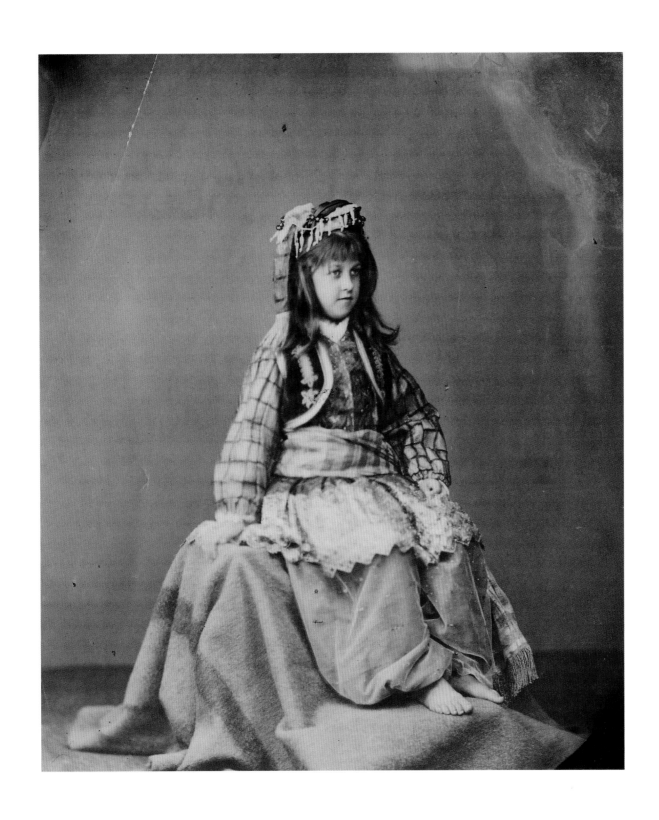

*Ethel in Eastern dress, 1877.*

# MORE CHILD FRIENDS

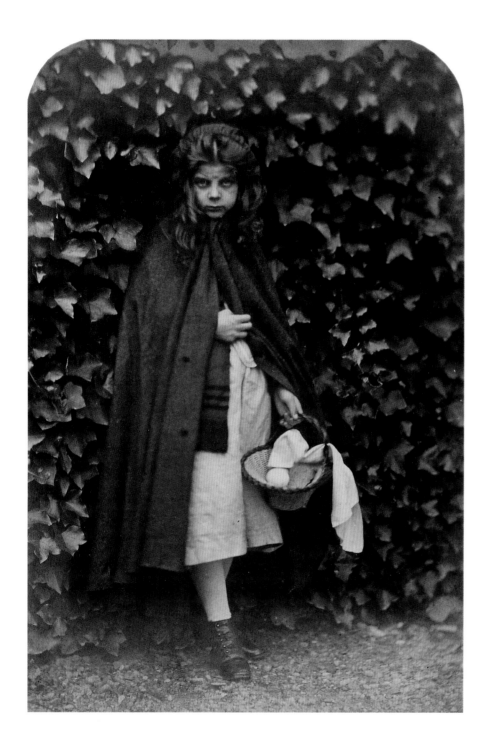

*Agnes Grace Weld as Little Red Riding Hood, 1857.*

When one young friend asked Lewis Carroll whether children ever bored him, he replied: "They are three-fourths of my life," and added that he could not understand how anyone could be bored by children. "Next to conversing with an angel . . . comes, I think, the privilege of having a *real* child's thoughts uttered to one," Carroll wrote to another friend. "I have known some few *real* children . . . and their friendship is a blessing and a help in life."

## LITTLE RED RIDING HOOD

Into the wood—the dark, dark wood—
    Forth went the happy Child;
And, in its stillest solitude,
    Talked to herself, and smiled;
And closer drew the scarlet Hood
    About her ringlets wild.

And now at last she threads the maze,
    And now she need not fear;
Frowning, she meets the sudden blaze
    Of moonlight falling clear;
Nor trembles she, nor turns, nor stays,
    Although the Wolf be near.

                —LEWIS CARROLL

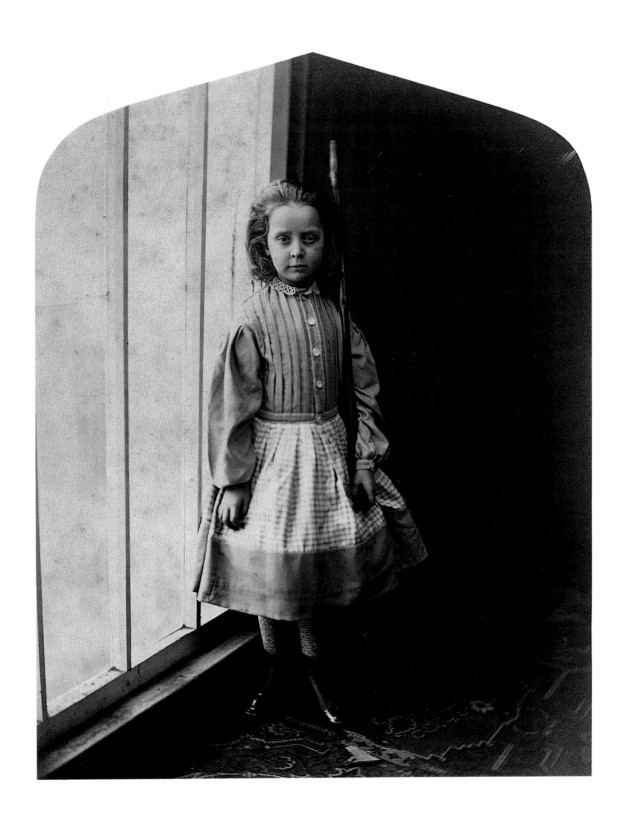

*Ella Chlora Faithful Monier-Williams (1859–1954) was the only daughter of (Sir) Monier Monier-Williams, the Orientalist. Carroll photographed Ella in May 1866. Ella later reminisced about Carroll: ". . . he gave one the sense of such perfect understanding, and this knowledge of child nature was the same whether the child was only seven years of age, or in her teens. . . . A visit to Mr. Dodgson's rooms to be photographed was always full of surprises."*

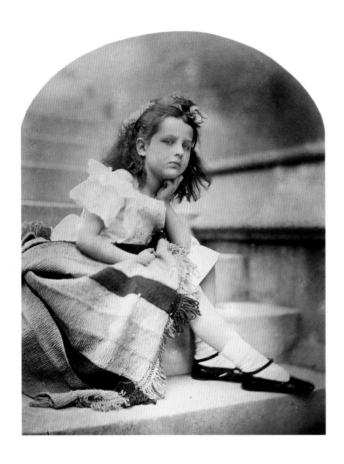

*Alice Constance*

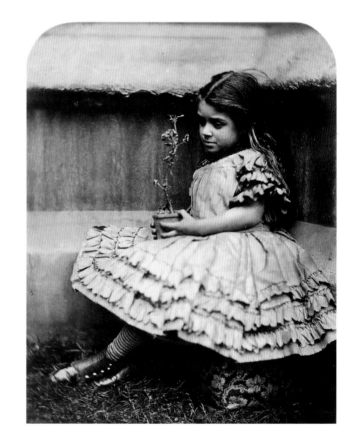

*MARIA WHITE*

*Alice Constance Westmacott was the daughter of Robert Westmacott (1799–1872), sculptor and Professor of Sculpture at the Royal Academy. "Mr. Westmacott sent four of his children [over] to Lambeth [Palace], of all of whom I got good pictures," Carroll wrote in his diary on July 9, 1864. "About 5 I went to the Westmacotts to get signatures in my album."*

*"Took pictures of . . . a little niece of the porter at the gate [of Tom Quadrangle, Christ Church], Maria White by name, who sat capitally," Carroll wrote in his diary on July 11, 1864.*

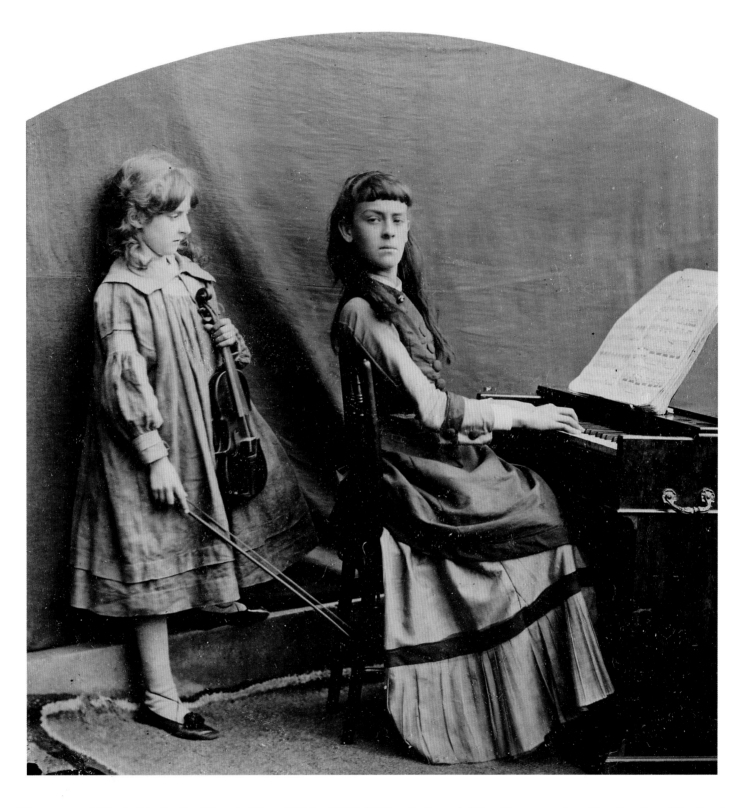

*Carroll became a good friend of the family of the artist Henry Holiday (1839–1927), who illustrated Carroll's nonsense poem* The Hunting of the Snark, *and he used the Holiday home as a photography studio. Henry Holiday's only child, Winifred (1865–1949) was a violinist. Here she is posed with Daisy Whiteside at the organ, in an image Carroll titled "The Lost Chord." Winifred remembered that when Carroll "stayed with us he used to steal on the sly into my little room after supper, and tell me strange impromptu stories as I sat on his knee in my nightie. It was very nice to be one of his little girls. . . . Mr. Dodgson . . . always took photographs of everyone and had to have a cellar all to himself for a dark room whenever he came to stay; . . . [he] was my parents' loved friend as well as my adored one . . . always the same gentle-voiced, quietly happy, and whimsical soul, his faint stammer and slight touch of Oxford dryness of manner only serving to enhance his charm." Winifred earned a scholarship to the Royal College of Music and later was an orchestra conductor.*

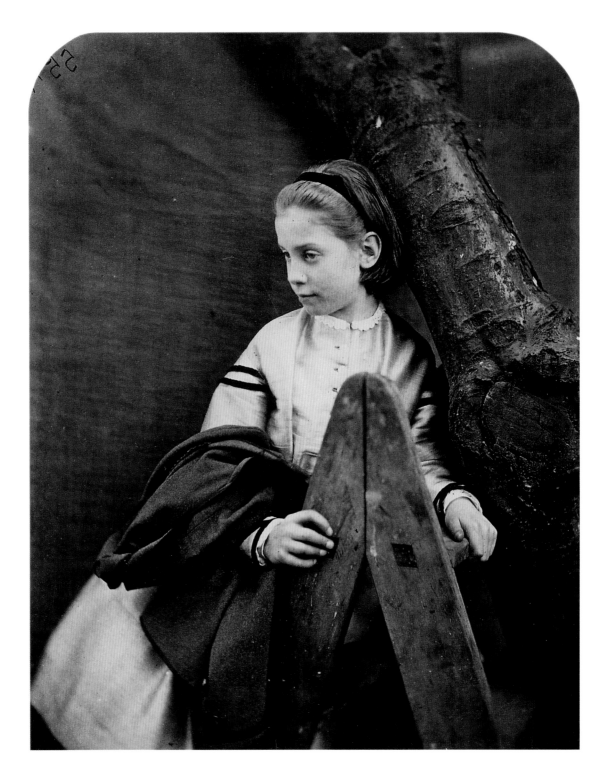

*Aileen*

Still at home at Croft for the summer vacation, on September 4, 1865, Carroll recorded in his
diary: "Mrs. Todd brought over her children . . . to be photographed—Lizzie, Aileen, and Evelyn.
I got a good one . . . of Evelyn and a tolerably successful one of the others in a group." Although
he does not mention a portrait of Aileen, he took this one of her and dated it.

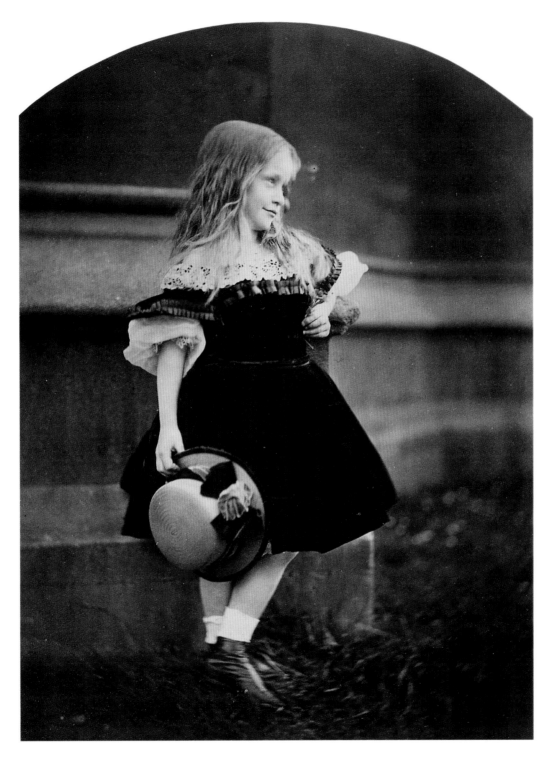

*Beatrice Henley.*

"The two little Henleys (children of the Vicar), Constance and Beatrice, came over," Carroll wrote while staying with his Uncle Hassard Dodgson and family in Putney on September 1, 1862. "I have undertaken to photograph them. . . ." He took this portrait of Beatrice Mary (1859–1941) in July 1864. Her father was Robert Henley (1831–1910), Vicar at Putney. This portrait is clearly one of Carroll's photographic masterpieces.

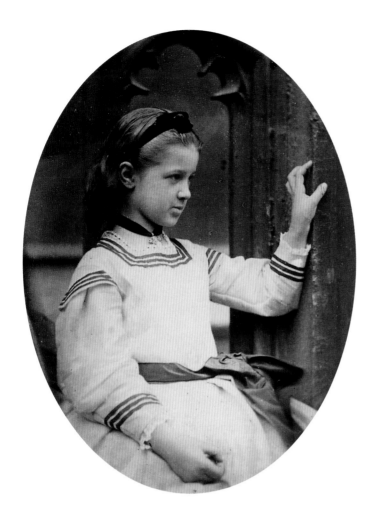

*Madeline Catherine Parnell*

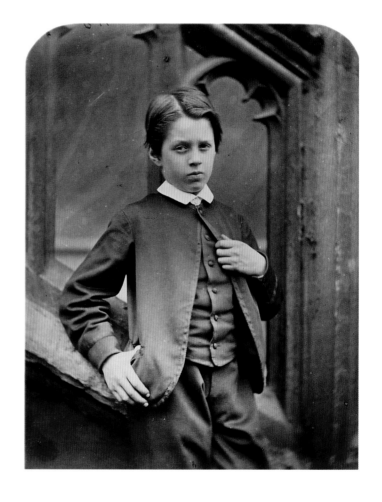

Madeline Catherine Parnell (1855–1925) was the daughter of (Sir) Henry William Parnell (1809–1896) later 3rd Baron Congleton, cousin of the Irish Nationalist Charles Stewart Parnell. Madeline was also the niece of Mrs. Longley. Carroll photographed her at Lambeth Palace on July 7, 1864.

Victor Alexander Lionel Dawson Parnell (1852–1936) was Queen Victoria's godson. Carroll photographed him at Lambeth Palace on July 7, 1864.

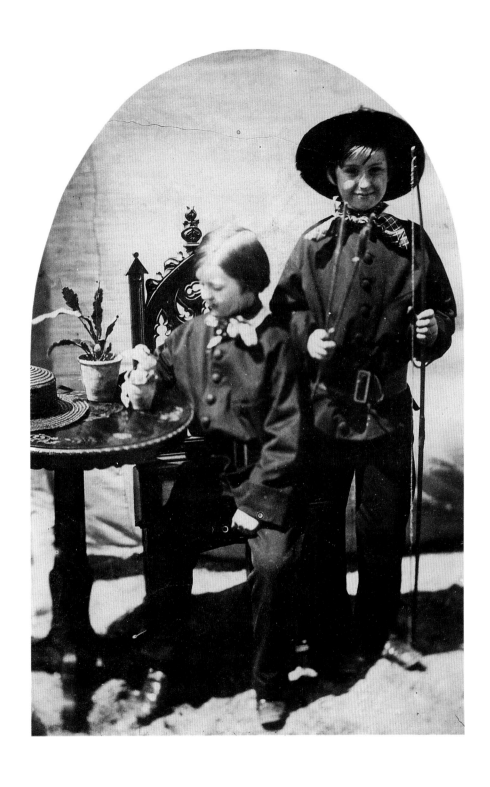

*Julia Margaret Cameron (1815–1879), the famous photographer, and her husband, the jurist Charles Hay Cameron (1795–1880), were neighbors of the Tennysons on the Isle of Wight, and Carroll met them and their children on his visits to the island. On September 6, 1862, he photographed at the Camerons'. These are two of the Camerons' five sons.*

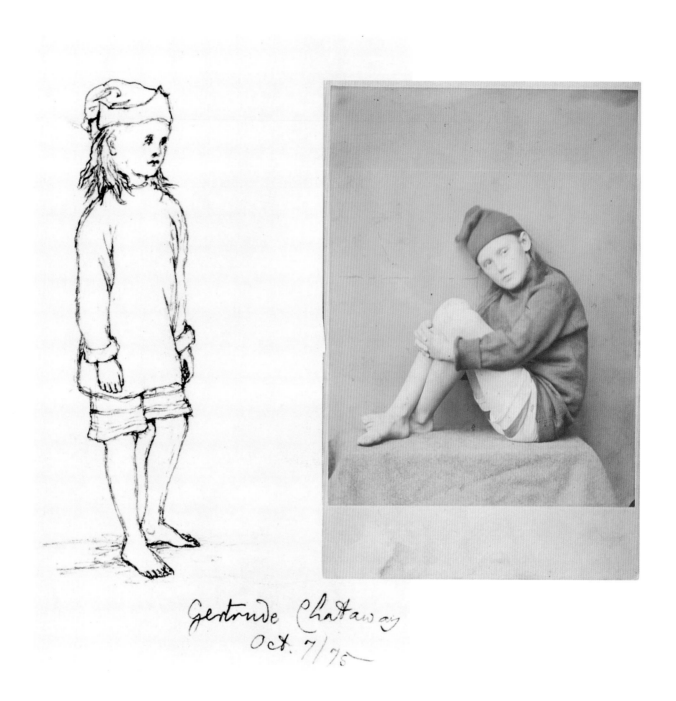

*Carroll first met Annie Gertrude Chataway (1866–1951) in September 1875 at Sandown on the Isle of Wight, where he had gone for a holiday. He later dedicated* The Hunting of the Snark *to Gertrude. The photograph was taken October 26, 1876.*

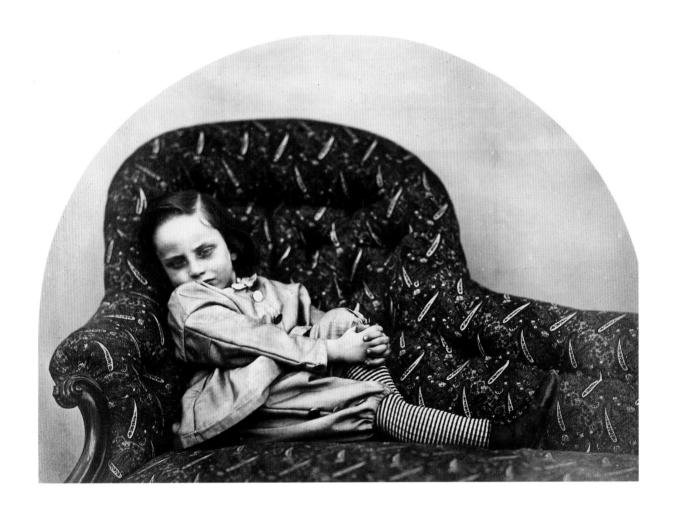

*Sidney George Owen (b. 1858), the son of Sidney James Owen (1827–1912), Tutor and Reader in Law and History at Christ Church. The son became a Christ Church don in 1891. On June 27, 1863, Carroll wrote in his diary: "Photographed the young Owens in the morning. . . ."*

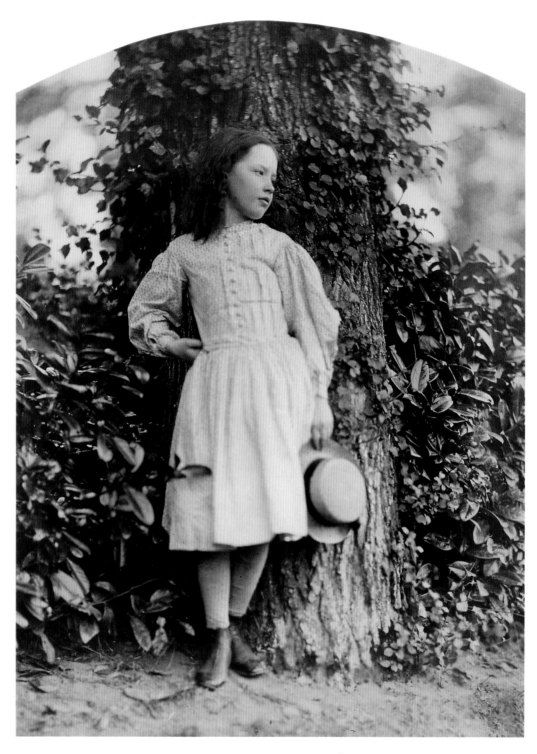

*Mary Ellis*

Mary Ellis, July 26, 1865. Mary's father, Conyngham Ellis (1817?–1891),
Vicar of Cranbourne, Berkshire, was one of Carroll's friends-in-photography.

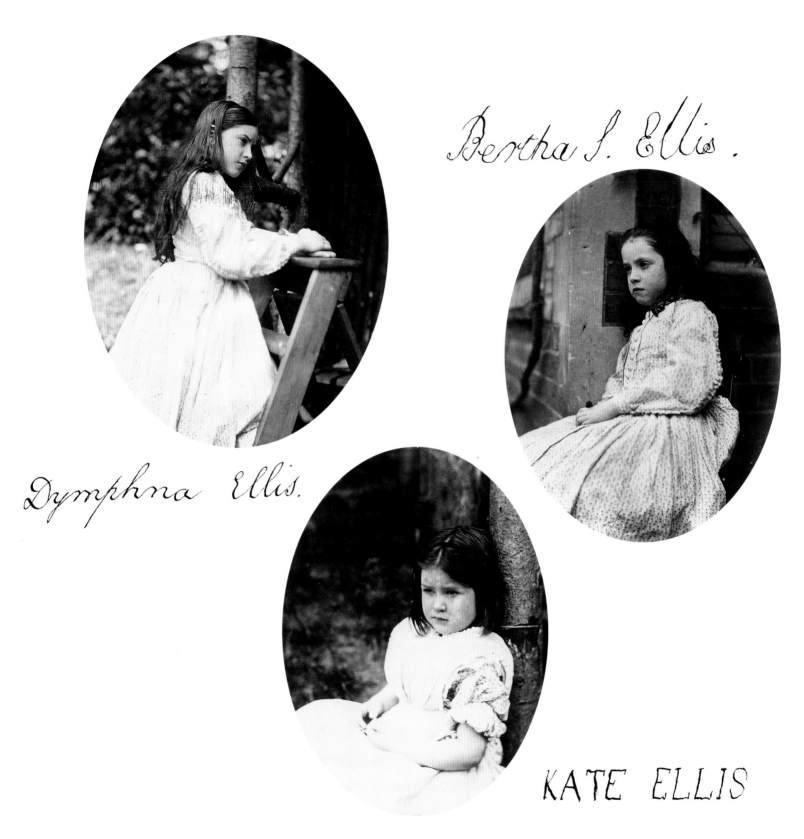

*Bertha S. Ellis.*

*Dymphna Ellis.*

KATE ELLIS

Above left: *The eldest of five children, Dymphna Ellis, later reminisced: "Lewis Carroll. . . came to our country home to photograph the children. . . . I feel sure I was a 'favourite.' He made every child that. He developed the photographs in our cellar. . . . I remember the mess and the mystery. . . . We cried when he went away. . . . We were absolutely fearless with him. We felt he was one of us, and on our side against all the grown-ups."* Above right: *Bertha Ellis.* Above: *Another Ellis daughter, this one named Kate.*

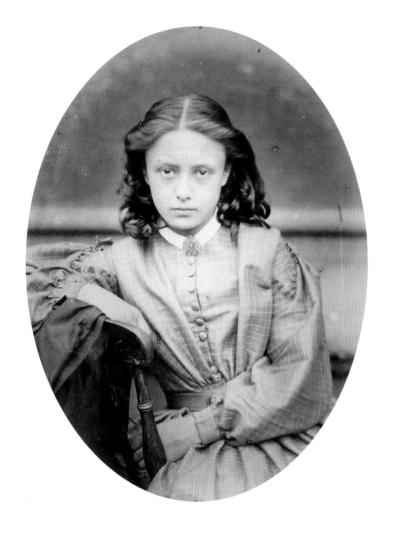

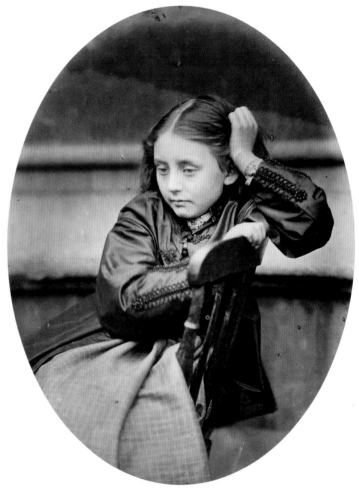

*The Balfours were friends from home in the north, but they must have been in London in July 1864, when Carroll photographed them at Lambeth Palace. Left is Georgina "Gina" Mary Balfour (1851–1929), whose father was Headmaster of a grammar school near Durham. Ella Sophia Anna Balfour (1854–1935), right, taken also at Lambeth Palace the same day as her sister, July 5, 1864.*

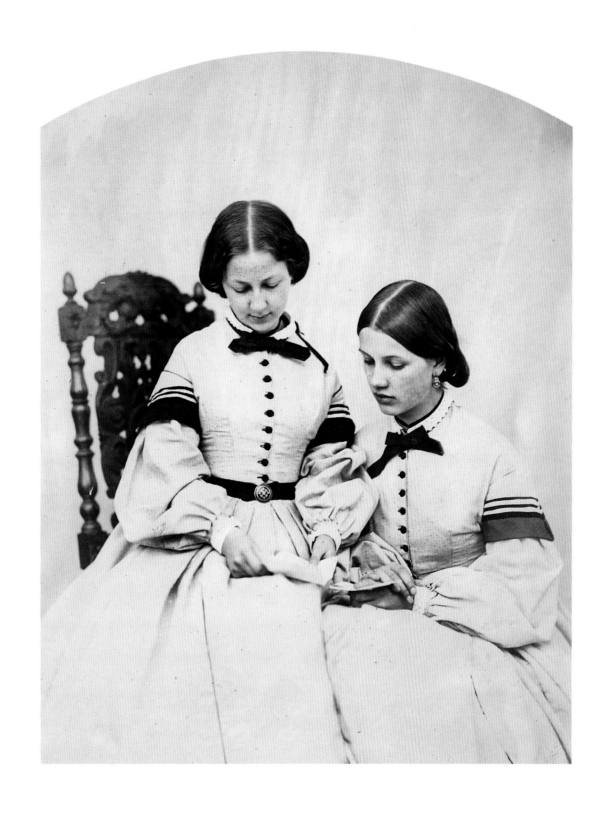

*"News from Home,"* 1863.

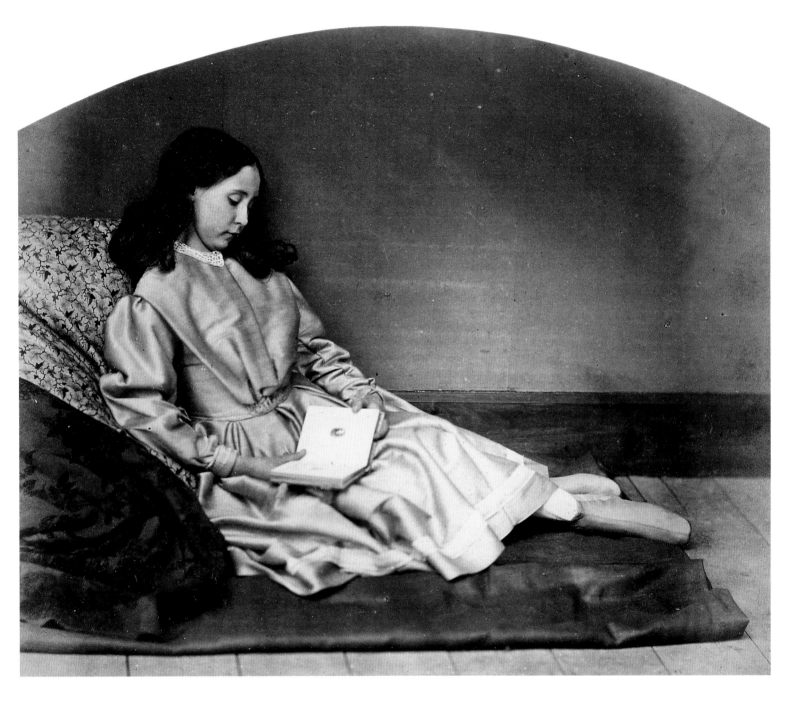

*Eliz^th Ley Hussey*

"Photographed Mrs. Hussey (widow of the late [Regius] Professor [of Ecclesiastical History]) and Bessie, aged 12," Carroll wrote in his diary on April 26, 1864. "Bessie" was Elizabeth Ley Hussey.

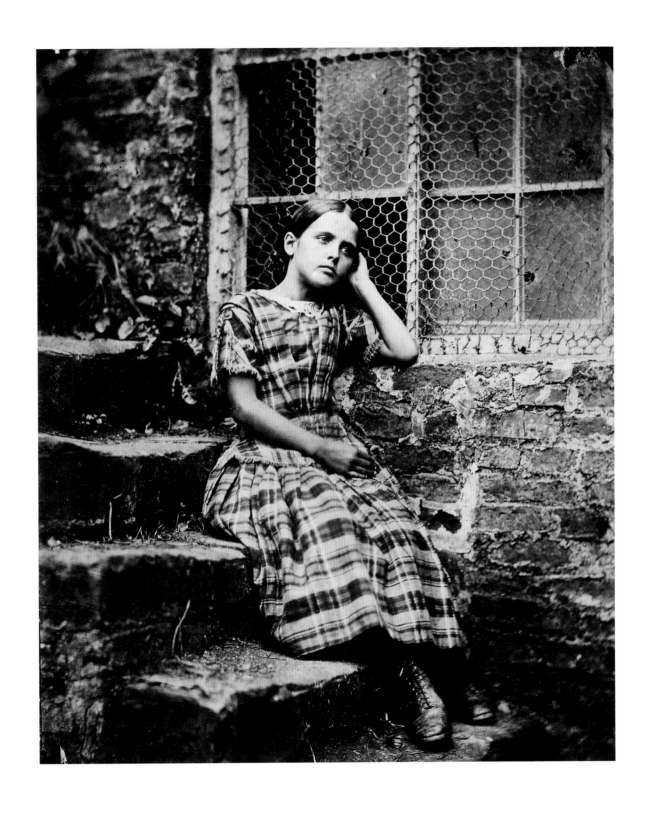

*Annie Coates, daughter of William and Isabella Coates, poulterer and grocer in Croft, 1857.*

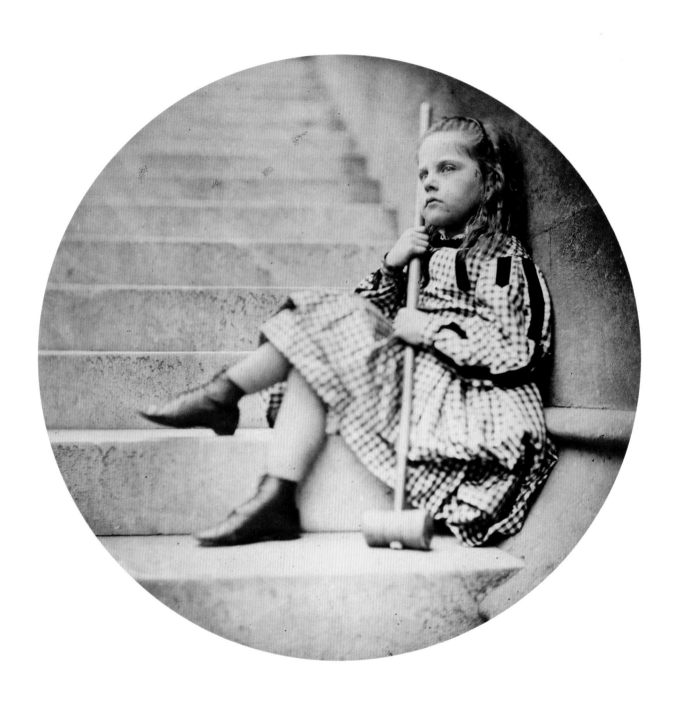

*"On reaching Lambeth [Palace]," Carroll writes in his diary on July 8, 1864, "found Mrs. Denman and her three children. . . . She left the three children, whom I went on photographing. . . ." Grace (1858–1935) was actually the fourth of six children of George Denman (1819–1896), M. P., Judge of the High Court.*

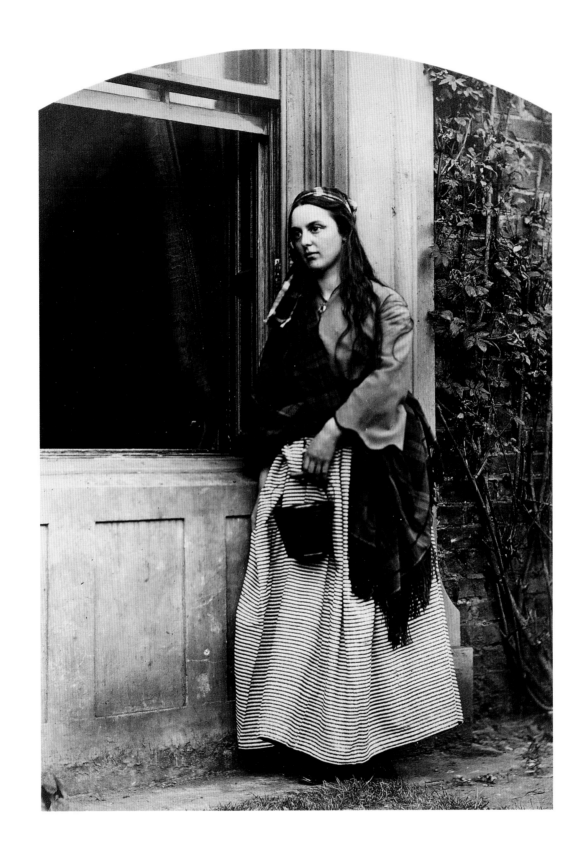

*Rose Wood (née Fawcett), of Hollin Hall, taken in the Croft Rectory garden and dated September 1865.*

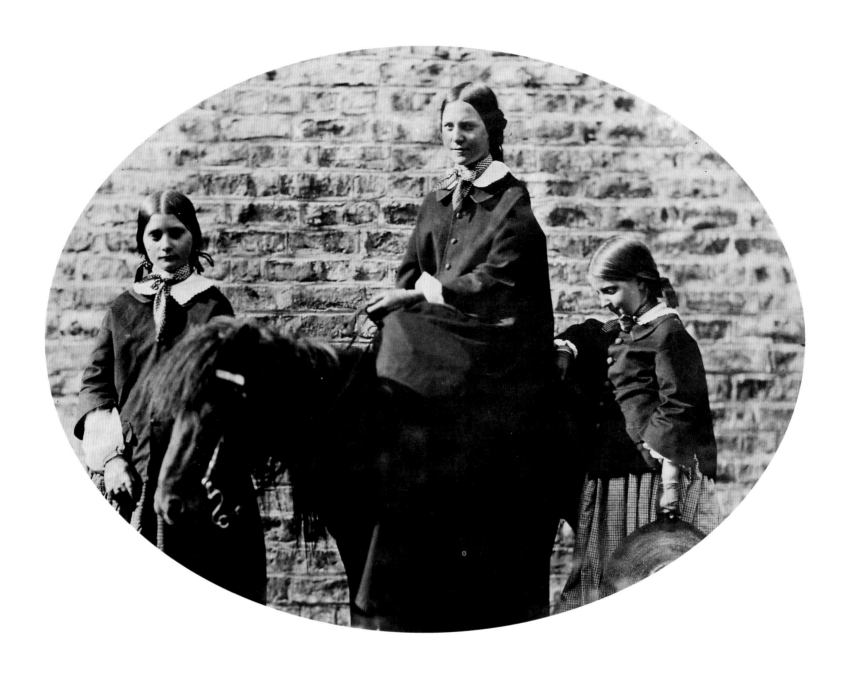

*"Dined with Mr. Smith of Dinsdale," Carroll wrote in his diary on June 26, 1856. ". . . Spent most of the evening with the children who have grown out of my recollection. Their names are most unpoetical: Maria, Johanna, Fanny and Ann. . . ." Five days later, Carroll and his brother Skeffington "walked over . . . to Dinsdale. . . . I took some of my photographs to show them and arranged that a party of them are to come on Friday to sit." The father of the family was John William Smith (1811–1897), Curate of Dinsdale. These are three of the poorly named Smiths with an unidentified pony.*

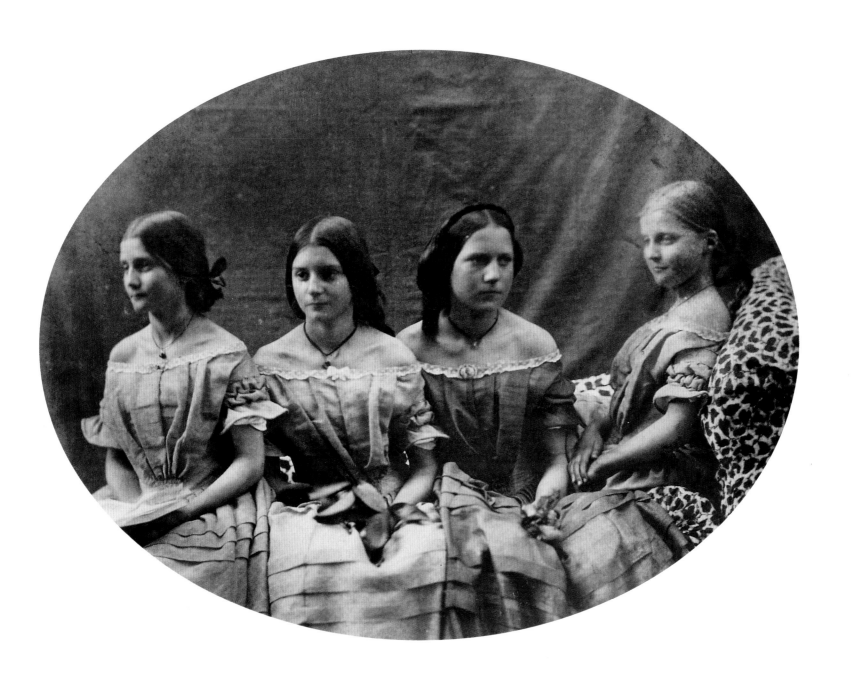

*The Smith sisters—Maria, Johanna, Fanny, and Ann—in 1857.*

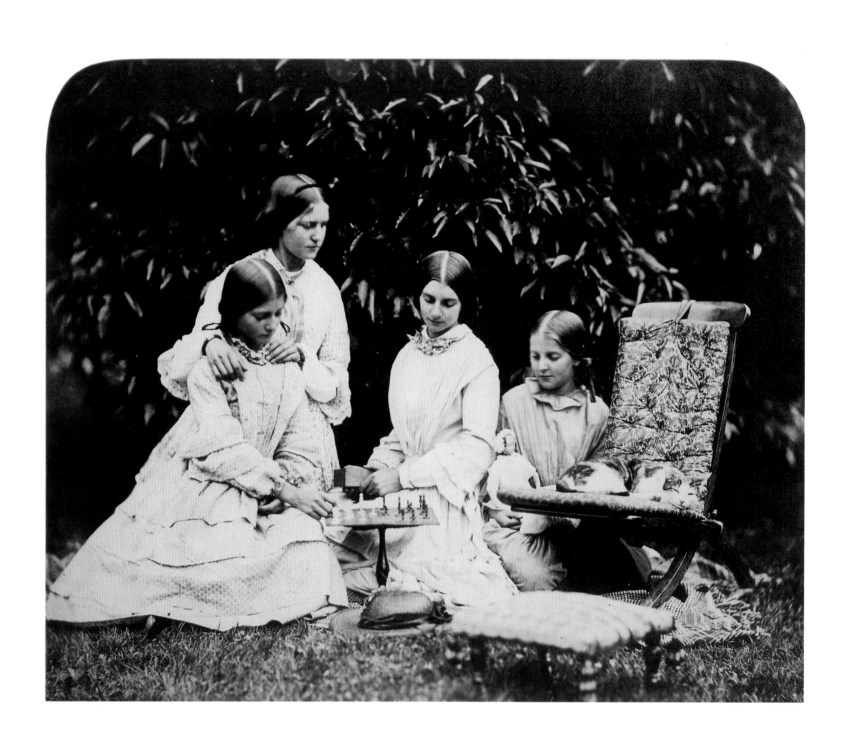

*Another combination of the Smith daughters, playing chess in the Dinsdale Rectory garden, 1859.*

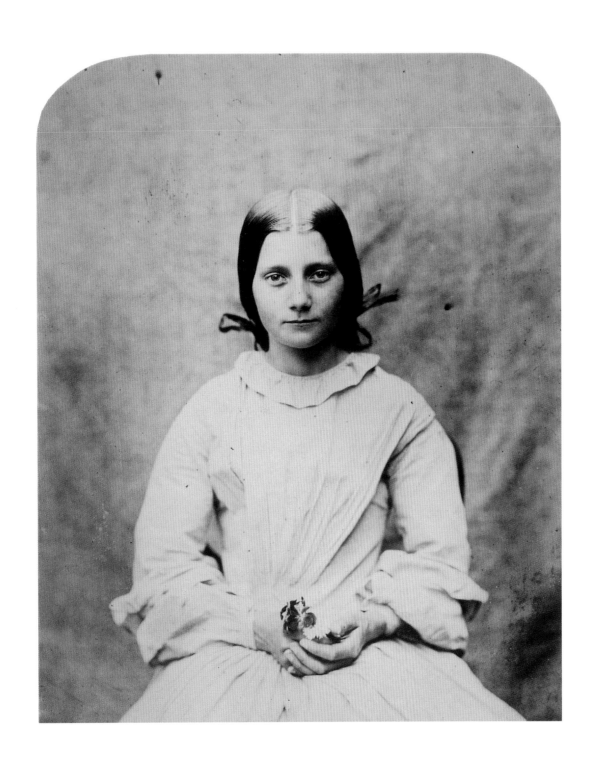

*Fanny Smith, Dinsdale, 1859.*

# LION HUNTING

Lewis Carroll was sensitive about his privacy and did not allow strangers to invade it. In fact he returned, unopened, letters that arrived at Christ Church, Oxford, addressed to Lewis Carroll. On the other hand, he was bold and fearless when it came to tracking down luminaries to sit for his camera, and he frequently succeeded in the hunt.

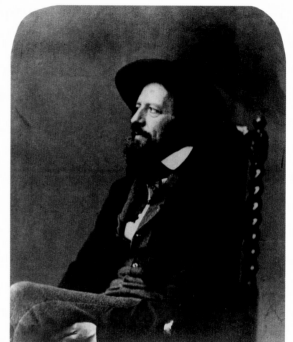

*Alfred, Lord Tennyson, 1857.*

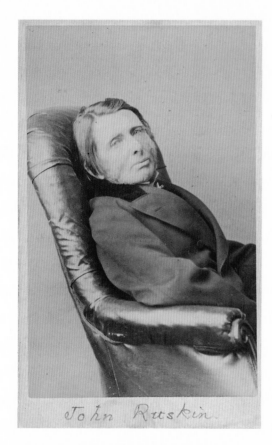

*Carroll admired the works of John Ruskin early; he finally encountered him at Christ Church on October 27, 1857, and they met frequently after that. It was Ruskin who told Carroll that he did not have the skill of a true pen-and-pencil artist, a judgment that might have encouraged Carroll to turn to photography.*

*When Carroll took his camera to the Isle of Wight, he photographed the Poet Laureate and his wife in the garden of their home, Farringford, ca. 1864.*

*In September 1857, the year after he acquired his camera, Lewis Carroll called on Alfred Tennyson and his family while visiting friends in the Lake District. To his surprise and delight, he was permitted to photograph virtually everyone in sight. His portrait of Hallam (1852–1928) erect on a chair is surely one of his great photographic achievements.*

*Carroll also recorded his initial impression of the Poet Laureate: "After I had waited some little time [in the drawing-room], the door opened, and a strange, shaggy-looking man entered: his hair, moustache and beard looked wild and neglected. . . . His hair is black: I think the eyes are too; they are keen and restless—nose aquiline—forehead high and broad; both face and head are fine and manly. His manner was kind and friendly . . . [with] a dry lurking humour in his style of talking."*

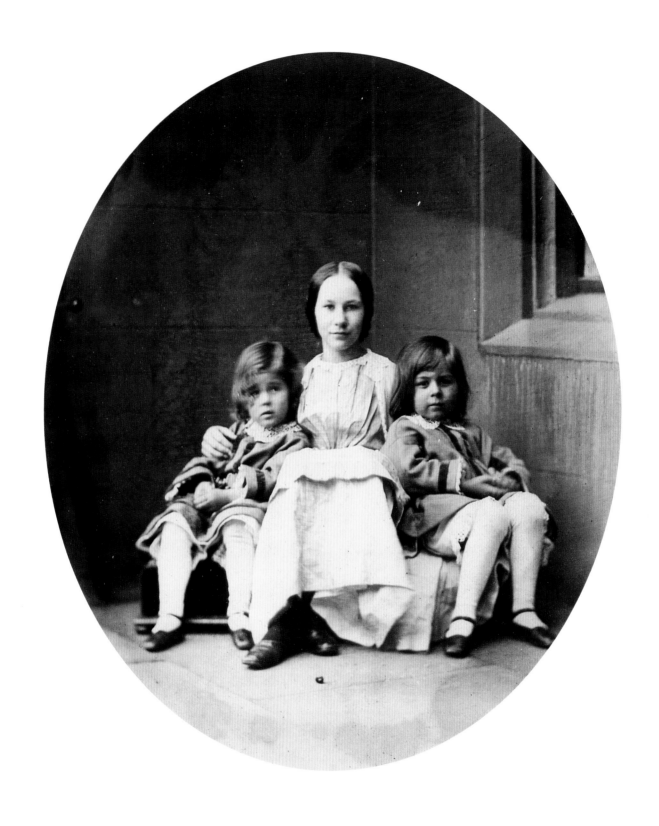

*Hallam and Lionel Tennyson (1854–1886), taken here with Julia Marshall (1846–1907), the daughter of the Tennysons' host, were, in Carroll's words, "the most beautiful boys of their age I ever saw." Carroll took this photograph on September 28, 1857.*

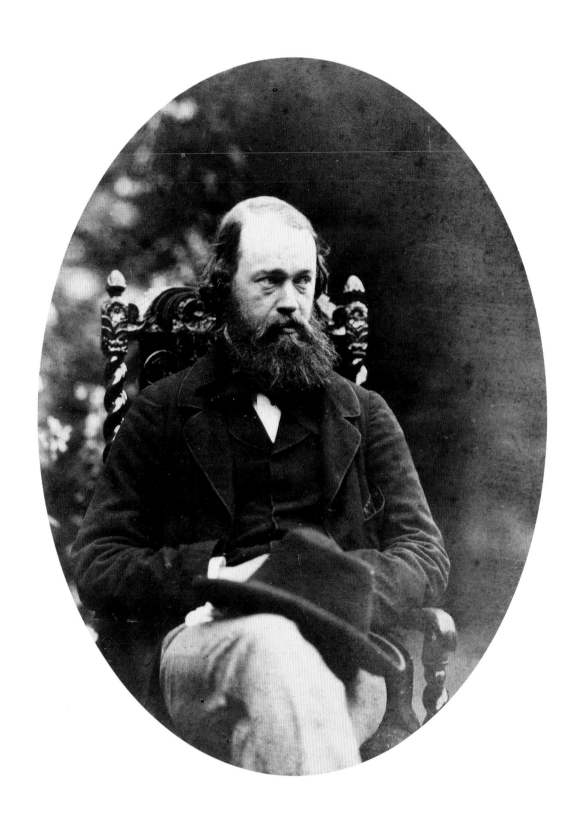

*Edmund Law Lushington (1811–1893), professor of Greek at Glasgow University, married Tennyson's sister, Celia, in 1842. This portrait was made in 1857.*

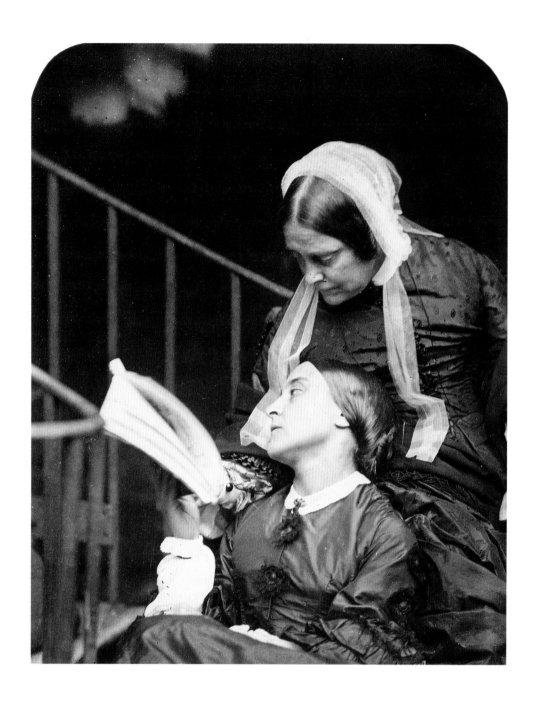

*Frances Rossetti and Christina G. Rossetti, 1863. "All my photographic victims seem to be available,"*
*Lewis Carroll wrote in his diary on September 29, 1863. On the following day, his friend the sculptor*
*Alexander Munro took him to call on Dante Gabriel Rossetti, "who was," Carroll noted, "most hospitable*
*in his offer of the use of house and garden for picture-taking." Carroll then photographed all the Rossettis,*
*Dante Gabriel, William Michael, Maria Francesca, Christina, and their mother, Frances, in various*
*poses. On October 7, 1863, Carroll wrote in his diary: "Spent the day at Mr. Rossetti's, photographing.*
*Took groups, and some single ones, of himself, and his mother, two sisters, and brother William."*

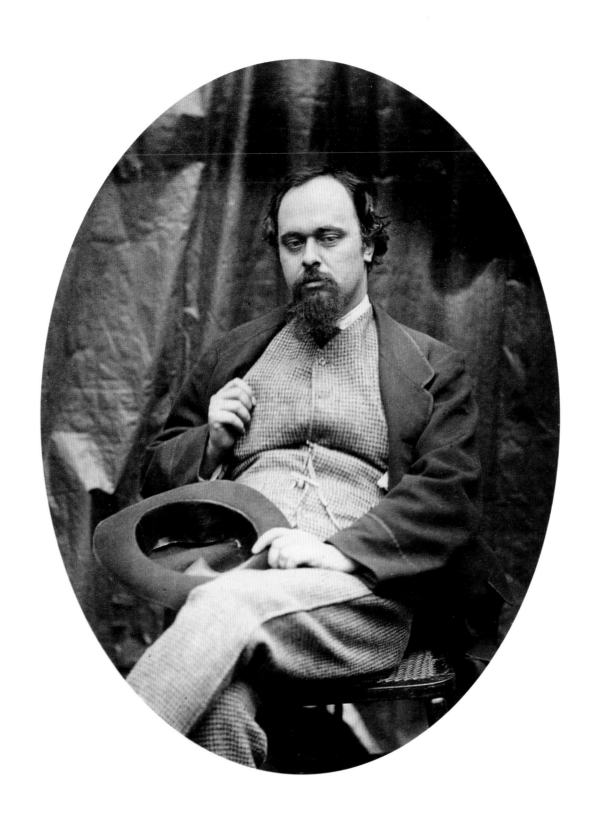

*Dante Gabriel Rossetti, 1863.*

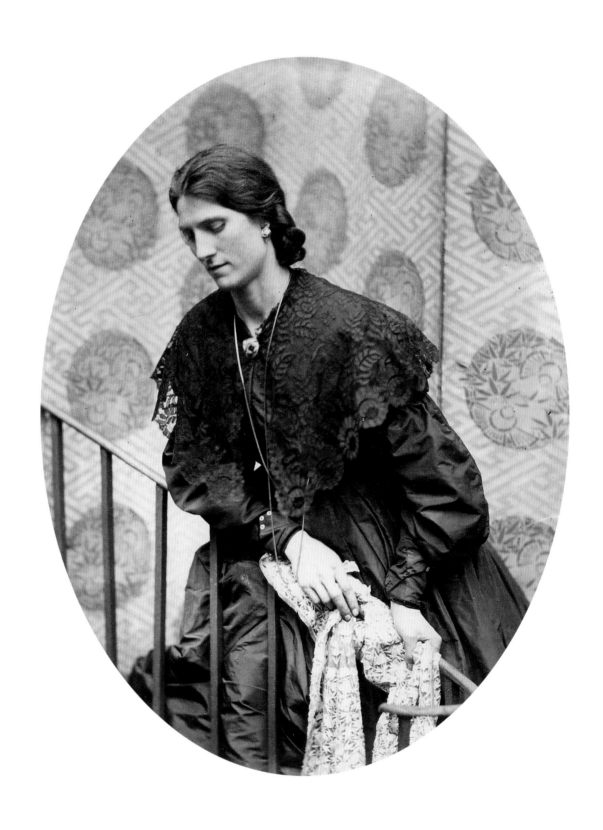

*On October 9, 1863, Carroll went to Rossetti's home in Cheyne Walk, "where I took several photographs of a Madame [Helene] Beyer, a model of Mr. Munro's . . . and of Mr. Rossetti."*

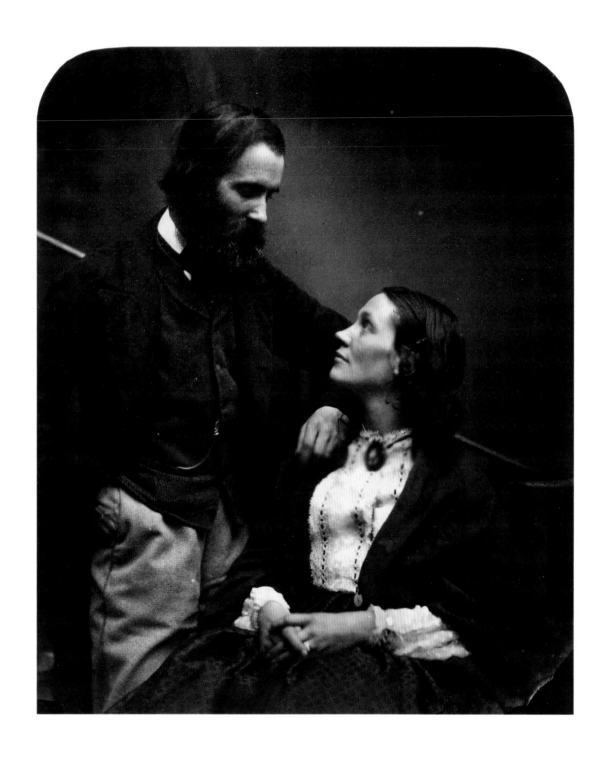

*An Oxford friend and colleague asked Lewis Carroll to bring over his photographic kit to show to the visiting sculptor Alexander Munro (1825–1871), who then invited Carroll to use his London studio for his photographing. Carroll took this photograph of Munro and his wife at the Rossetti home on Cheyne Walk in 1863.*

*Carroll admired the work of Arthur Hughes (1832–1915) and bought at least one of his paintings,* The Lady of the Lilacs. *On October 12, 1863, Hughes and his children came over to the MacDonalds' and Carroll photographed them. Here are Arthur and Agnes Hughes.*

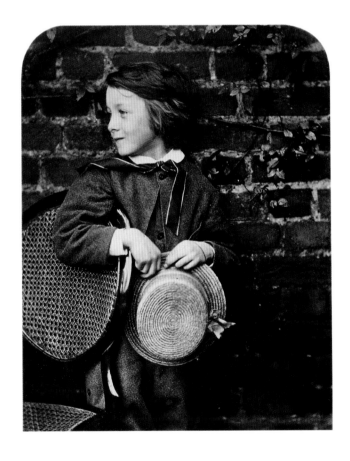

*Carroll later photographed the Hugheses at Lambeth Palace, where he had an entrée through the services of C. T. Longley, then Archbishop of Canterbury. The children here are Amy and Arthur Jr.*

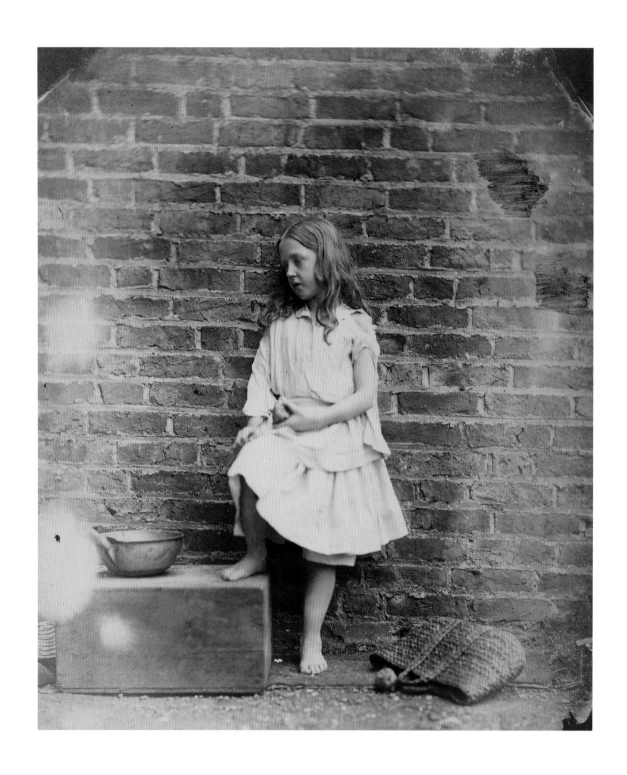

*Carroll made numerous attempts to photograph Ellen Terry and her actor family,
and he finally succeeded in getting them to sit for him on four successive days
in July 1865. Here is Florence "Flo" Maud Terry (1855–1896) paring fruit.*

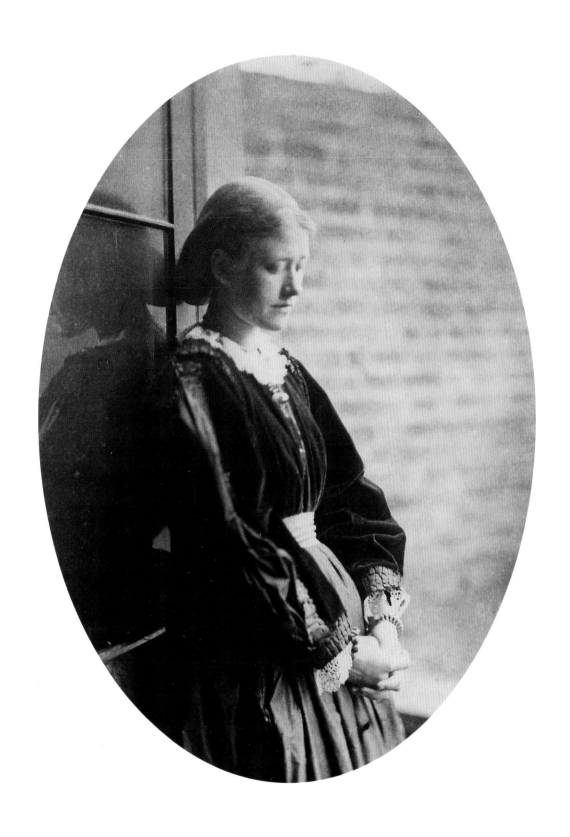

*He took this photograph of the famous (Dame) Ellen Terry (1847–1928) on the balcony of the Terry home in London, 1865.*

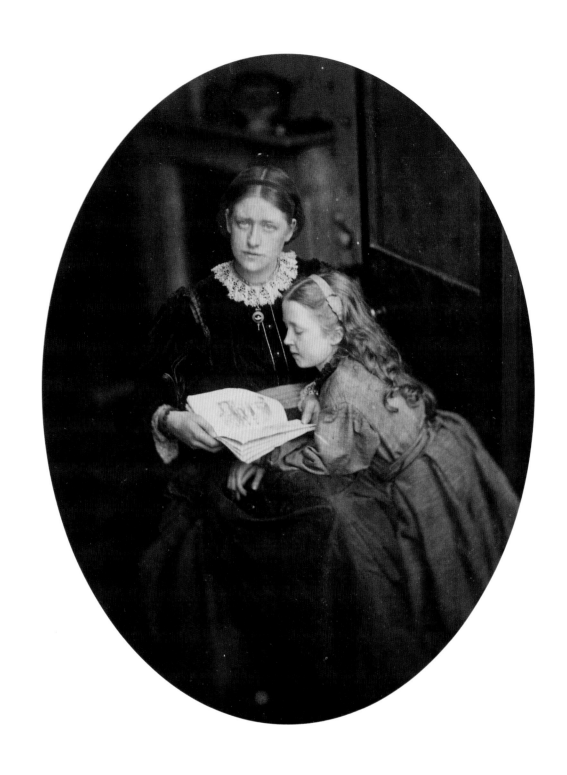

*Ellen Terry seated with her sister Florence, July 13, 1865.*

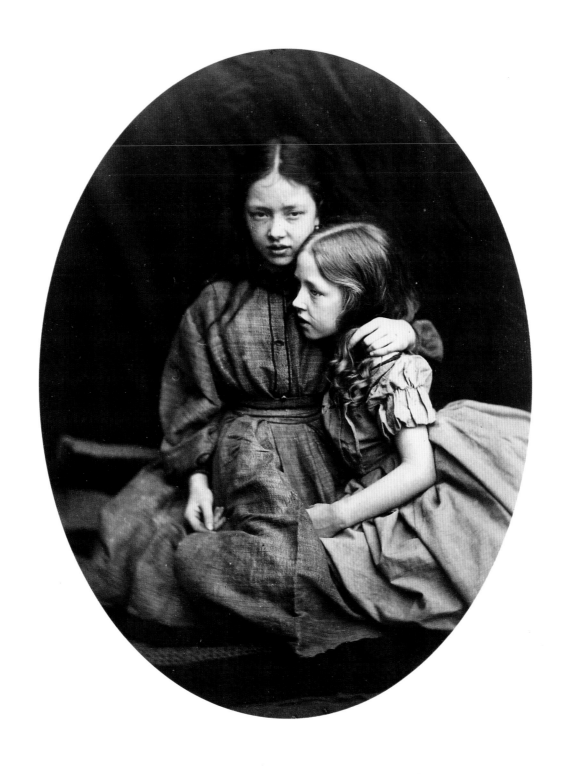

*Flo (with hair ribbon removed) is joined by a still younger sister, Mary Ann "Polly" Terry (1853–1930), July 14, 1865.*

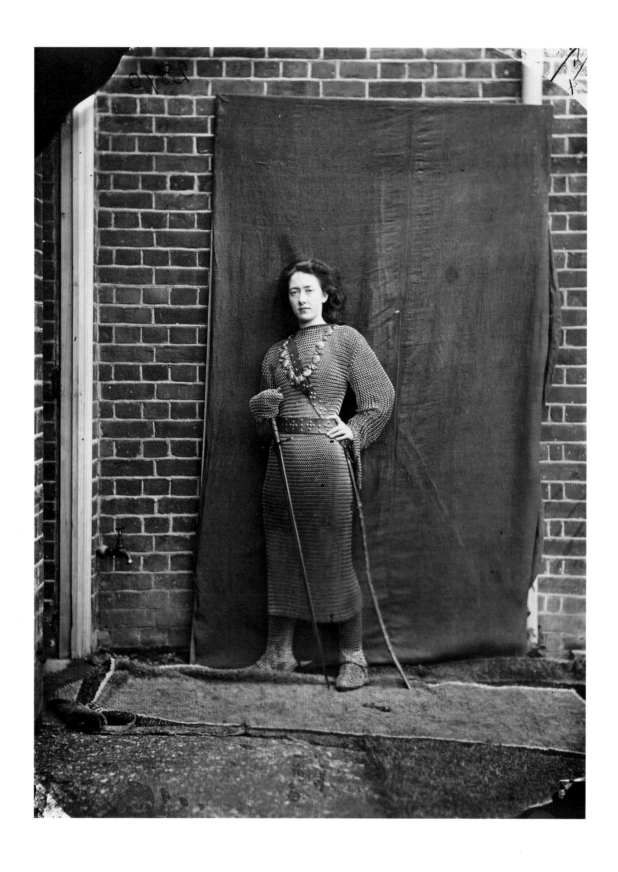

*Mary Ann became Marion in time; here she is dressed in chain armor, July 1875. Beneath the portrait, Carroll added this couplet from Sir Walter Scott's* The Lady of the Lake: *"Come one, come all! This rock shall fly / From its firm base as soon as I!"*

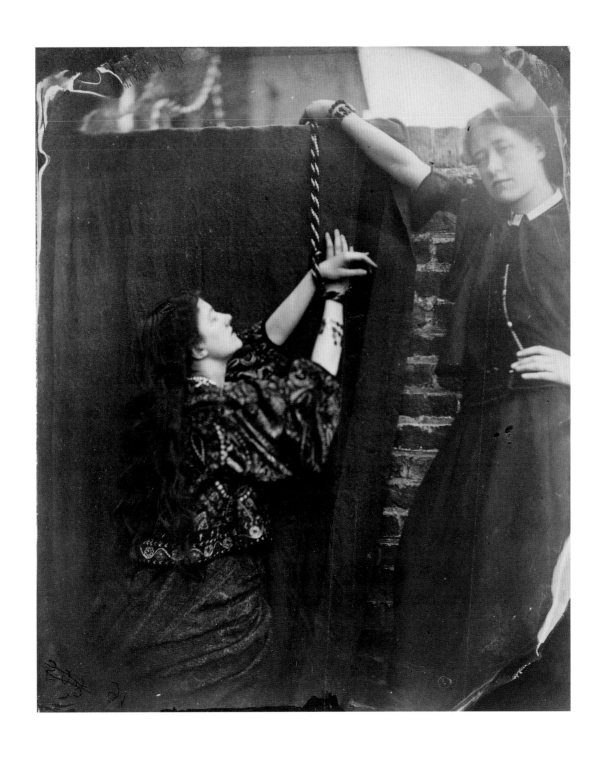

*Eliza Murray Kate Terry (1842–1924), Ellen's younger sister, was also an actress. Here she is dressed as Andromeda, chained to a rock to appease a Greek god. The second figure is probably sister Ellen.*

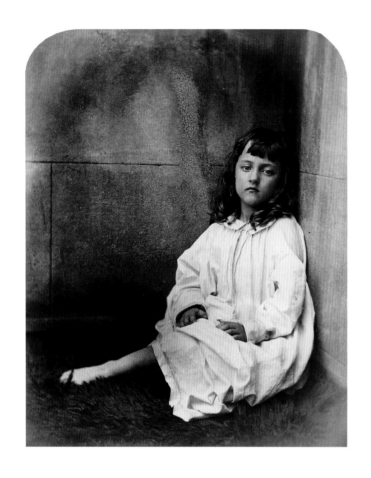

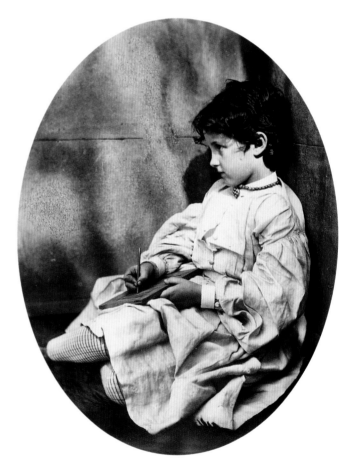

*Mary Hunt Millais (1860–1944), 1865.*

*Effie Millais, named after her mother, also in 1865.*

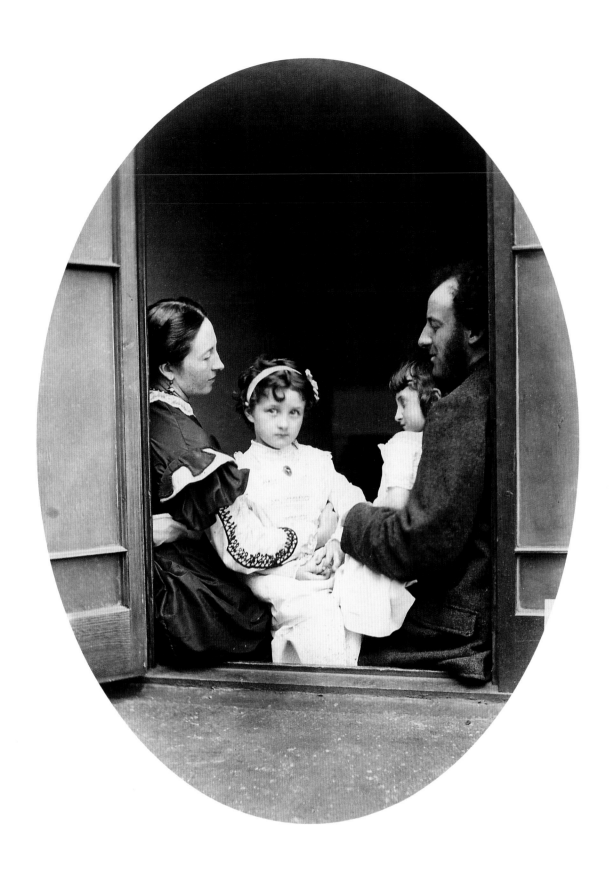

*(Sir) John Everett Millais, Mrs. Millais (Euphemia Chalmers Gray [1828–1897]), and two of their children. Carroll took the photograph at the Millais' home in London on July 21, 1865.*

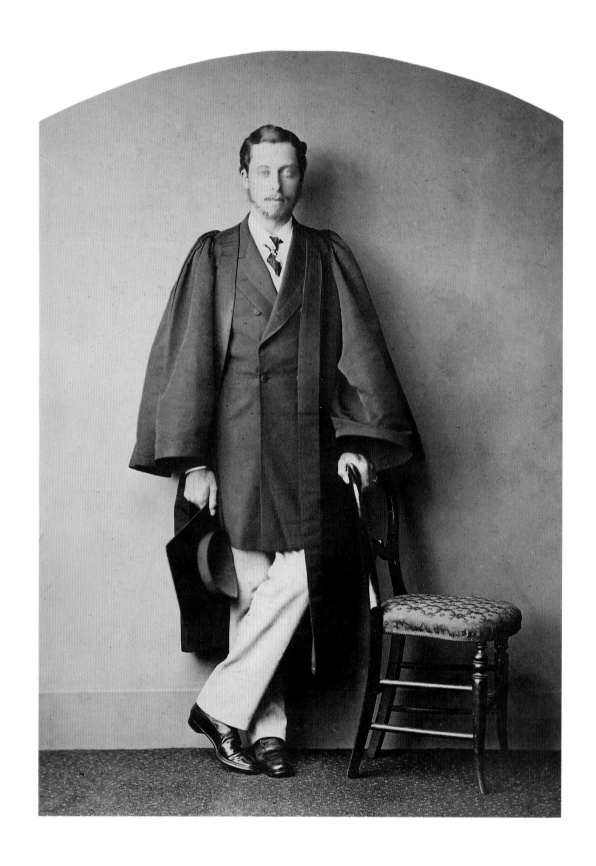

*Prince Leopold, June 2, 1875. Queen Victoria's youngest son, later Duke of Albany (1853–1884), was a Christ Church undergraduate. Carroll approached the Prince's tutor, asked if the Prince would consent to be photographed, and got a favorable reply. Later, Carroll became friendly with the Prince's widow, the Duchess of Albany, and their two children, Prince Charles and Princess Alice.*

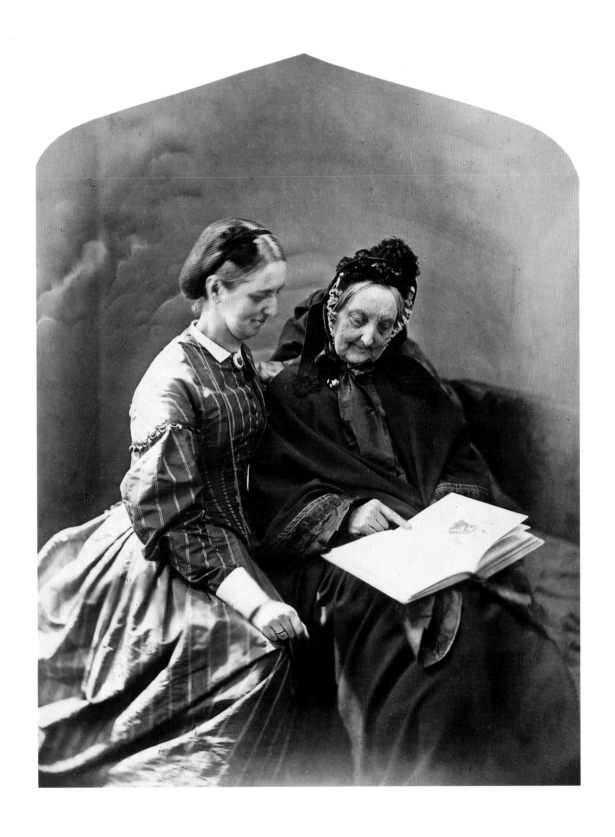

*Carroll admired both the novels and children's stories by Charlotte Mary Yonge (1823–1901). He gave a copy of her* Scenes and Characters *as a birthday present to Alice Liddell, and he sent Miss Yonge an inscribed copy of* Alice. *On May 3, 1866, he met Miss Yonge at a luncheon party: "It was a pleasure I had long hoped for," he wrote. On the following day, Miss Yonge and her mother called on Carroll and he photographed them. Miss Yonge was so pleased with the result that she ordered more than two dozen copies. Later, Carroll published some of his puzzles and games in the* Monthly Packet, *which Miss Yonge edited.*

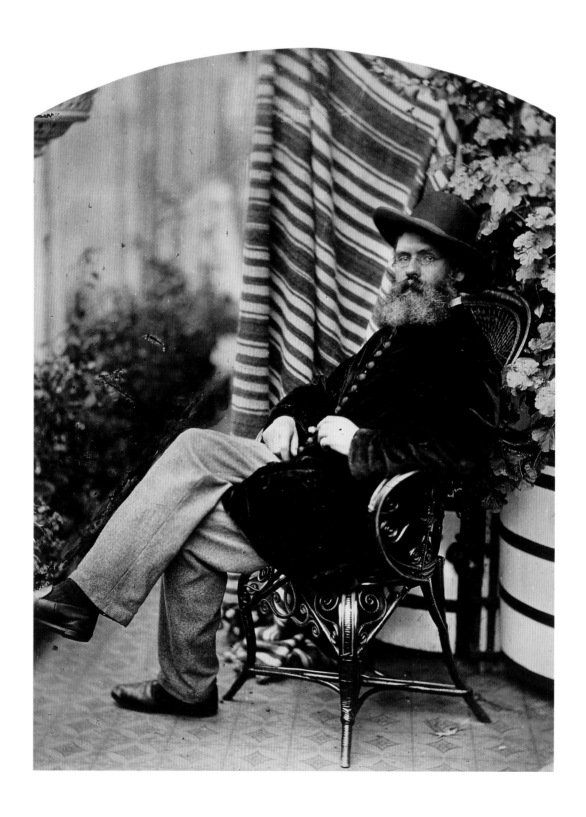

*Tom Taylor (1817–1880), the prolific and influential dramatist, was instrumental in introducing Carroll to the Terrys and to (Sir) John Tenniel, who later illustrated Carroll's* Alice *books. On October 3, 1863, Carroll, in London, "set off for Wandsworth in a fly soon after 8 . . . got [to the Taylors'] in about half an hour, before they had assembled for breakfast" and photographed the whole family.*

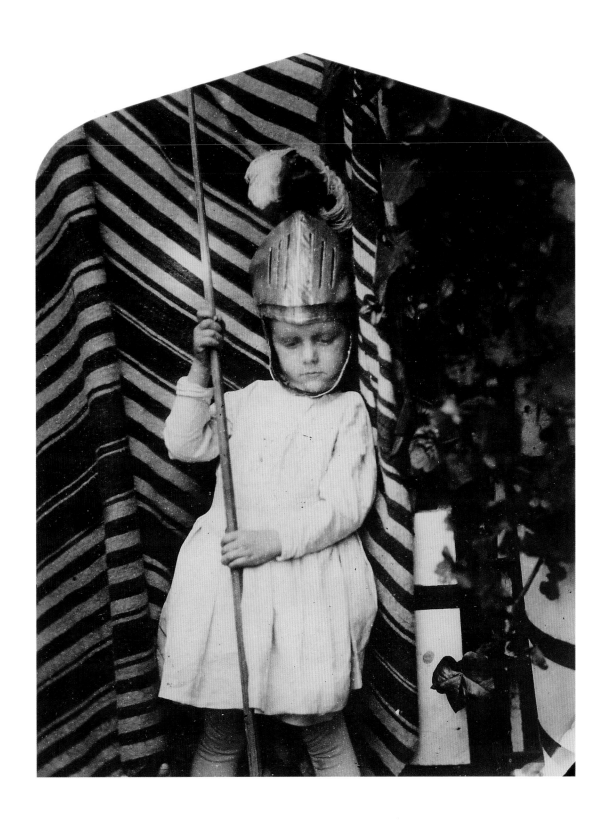

*Wicliffe Taylor, Tom Taylor's son, in armor, was one of Carroll's "victims."*

# A Photographer's Day Out

*Lewis Carroll*

I am shaken, and sore, and stiff, and bruised. As I have told you many times already, I haven't the least idea how it happened and there is no use in plaguing me with any more questions about it. Of course, if you wish it, I can read you an extract from my diary, giving a full account of the events of yesterday, but if you expect to find any clue to the mystery in *that*, I fear you are doomed to be disappointed.

*August 23, Tuesday.* They say that we Photographers are a blind race at best; that we learn to look at even the prettiest faces as so much light and shade; that we seldom admire, and never love. This is a delusion I long to break through–if I could only find a young lady to photograph, realizing *my* ideal of beauty–above all, if her name should be–(why is it, I wonder, that I dote on the name Amelia more than any other word in the English language?)–I feel sure that I could shake off this cold, philosophic lethargy.

The time has come at last. Only this evening I fell in with young Harry Glover in the Haymarket–"Tubbs!" he shouted, slapping me familiarly on the back, "my Uncle wants you down to-morrow at his Villa, camera and all!"

"But I don't know your uncle," I replied, with my characteristic caution. (N.B. If I have a virtue, it is quiet, gentlemanly caution.)

"Never mind, old boy, he knows all about *you*. You be off by the early train, and take your whole kit of bottles, for you'll find lots of faces to uglify, and–"

"Ca'n't go," I said rather gruffly, for the extent of the job alarmed me, and I wished to cut him short, having a decided objection to talking slang in the public streets.

"Well, they'll be precious cut up about it, that's all," said Harry, with rather a blank face, "and my cousin Amelia–"

"Don't say another word!" I cried enthusiastically, "I'll go!" And as my omnibus came by at the moment, I jumped in and rattled off before he had recovered his astonishment at my change of manner. So it is settled, and to-morrow I am to see an Amelia, and–Oh Destiny, what hast thou in store for me?

*August 24, Wednesday.* A glorious morning. Packed in a great hurry, luckily breaking only two bottles and three glasses in doing so. Arrived at Rosemary Villa as the party were sitting down to breakfast. Father, mother, two sons from school, a host of children from the nursery and the inevitable BABY.

But how shall I describe the daughter? Words are powerless; nothing but a Tablotype could do it. Her nose was in beautiful perspective–her mouth wanting perhaps the least possible foreshortening–but the exquisite half-tints on the cheek would have blinded one to any defects, and as to the high light on her chin, it was (photographically speaking) perfection. Oh! What a picture she would have made if fate had not– but I am anticipating.

There was a Captain Flanaghan present–

I am aware that the preceding paragraph is slightly abrupt, but when I reached that point, I remembered that the idiot actually believed himself engaged to Amelia (*my* Amelia!). I choked, and could get no further. His figure, I am willing to admit, was good: some might have admired his face; but what is face or figure without brains?

My own figure is perhaps a *little* inclined to the robust; in stature I am none of your military giraffes–but why should I describe myself? My photograph (done by myself) will be sufficient evidence to the world.

The breakfast, no doubt, was good, but I knew not what I ate or drank; I lived for Amelia only, and as I gazed on that peerless brow, those chiseled features,

I clenched my fist in an involuntary transport (upsetting my coffee-cup in doing so), and mentally exclaimed, "I will photograph that woman, or perish in the attempt!"

After breakfast the work of the day commenced, which I will here briefly record.

PICTURE 1.–Paterfamilias. This I wanted to try again, but they all declared it would do very well, and had "just his usual expression"; though unless his usual expression was that of a man with a bone in his throat, endeavouring to alleviate the agony of choking by watching the end of his nose with both eyes, I must admit that this was too favourable a statement of the case.

PICTURE 2.–Materfamilias. She told us with a simper, as she sat down, that she "had been very fond of theatricals in her youth," and that she "wished to be taken in a favourite Shakespearean character." What the character was, after long and anxious thought on the subject, I have given up as a hopeless mystery, not knowing any one of his heroines in whom an attitude of such spasmodic energy could have been combined with a face of such blank indifference, or who could have been thought appropriately costumed in a blue silk gown, with a Highland scarf over one shoulder, a ruffle of Queen Elizabeth's time round the throat, and a hunting-whip.

PICTURE 3.–17th sitting. Placed the baby in profile. After waiting till the usual kicking had subsided, uncovered the lens. The little wretch instantly threw its head back, luckily only an inch, as it was stopped by the nurse's nose, establishing the infant's claim to "first blood" (to use a sporting phrase). This, of course, gave *two* eyes to the result, something that might be called a nose, and an unnaturally wide mouth. Called it a full-face accordingly and went on to

PICTURE 4.–The three younger girls, as they would have appeared, if any possibility a black dose could have been administered to each of them at the same moment, and the three tied together by the hair before

the expression produced by the medicine had subsided from any of their faces. Of course, I kept this view of the subject to myself, and merely said that "it reminded me of a picture of the three Graces," but the sentence ended in an involuntary groan, which I had the greatest difficulty in converting into a cough.

PICTURE 5.–This was to have been the great artistic triumph of the day; a family group, designed by the two parents, and combining the domestic with the allegorical. It was intended to represent the baby being crowned with flowers, by the united efforts of the children, regulated by the advice of the father, under the personal superintendence of the mother; and to combine with this the secondary meaning of "Victory transferring her laurel crown to Innocence, with Resolution, Independence, Faith, Hope and Charity, assisting in the graceful task, while Wisdom looks benignly on, and smiles approval!" Such, I say, was the *intention*; the result, to any unprejudiced observer, was capable of but one interpretation–that the baby was in a fit–that the mother (doubtless under some erroneous notions of the principles of Human Anatomy), was endeavouring to recover it by bringing the crown of its head in contact with its chest–that the two boys, seeing no prospect for the infant but immediate destruction, were tearing out some locks of its hair as mementos of the fatal event–that two of the girls were waiting for a chance at the baby's hair, and employing the time in strangling the third–and that the father, in despair at the extraordinary conduct of his family, had stabbed himself, and was feeling for his pencil-case, to make a memorandum of having done so.

All this time I had no opportunity of asking my Amelia for a sitting, but during luncheon I succeeded in finding one, and, after introducing the subject of photographs in general, I turned to her and said, "before the day is out, Miss Amelia, I hope to do myself the honour of coming to *you* for a negative."

With a sweet smile she replied "certainly, Mr. Tubbs. There is a cottage near here, that I wish you would try

after luncheon, and when you've done that, I shall be at your service."

"Faix! an' I hope she'll give you a decoisive one!" broke in that awkward Captain Flanaghan, "wo'n't you, Mely Darlint?" "I trust so, Captain Flanaghan," I interposed with great dignity; but all politeness is wasted on that animal; he broke into a great "haw! haw!" and Amelia and I could hardly refrain from laughing at his folly. She, however, with ready tact turned it off, saying to the bear, "come, come, Captain, we mustn't be *too* hard on him!" (Hard on *me*! on *me*! bless thee, Amelia!)

The sudden happiness of that moment nearly overcame me; tears rose to my eyes as I thought, "the wish of a Life is accomplished! I shall photograph an Amelia!" Indeed, I almost think I should have gone down on my knees to thank her, had not the table-cloth interfered with my so doing, and had I not known what a difficult position it is to recover from.

However, I seized an opportunity toward the close of the meal to give utterance to my overwrought feelings: turning toward Amelia, who was sitting next to me, I had just murmured the words, "there beats in this bosom a heart," when a general silence warned me to leave the sentence unfinished. With the most admirable presence of mind she said, "some tart, did you say, Mr. Tubbs? Captain Flanaghan, may I trouble you to cut Mr. Tubbs some of that tart?"

"It's nigh done," said the captain, poking his great head almost into it, "will I send him the dish, Mely?"

"No, sir!" I interrupted, with a look that ought to have crushed him, but he only grinned and said, "don't be modest now, Tubbs, me bhoy, sure there's plenty more in the larder."

Amelia was looking anxiously at me, so I swallowed my rage—and the tart.

Luncheon over, after receiving directions by which to find the cottage, I attached to my camera the hood used for developing pictures in the open air, placed it over my shoulder, and set out for the hill which had been pointed out to me.

My Amelia was sitting in the window working, as I passed with the machine; the Irish idiot was with her. In reply to my look of undying affection, she said anxiously, "I'm sure that's too heavy for you, Mr. Tubbs. Wo'n't you have a boy to carry it?"

"Or a donkey?" giggled the captain.

I pulled up short, and faced round, feeling that now, if ever, the dignity of Man, and the liberty of the subject, must be asserted. To *her* I merely said, "thanks, thanks!" kissing my hand as I spoke; then, fixing my eyes on the idiot at her side, I hissed through my clenched teeth, *"we shall meet again, Captain!"*

"Sure, I hope so, Tubbs," said the unconscious blockhead, "sharp six is the dinner hour, mind!" A cold shiver passed over me; I had made my great effort, and had *failed*; I shouldered my camera again, and strode moodily on.

Two steps, and I was myself again; *her* eyes, I knew, were upon me, and once more I trod the gravel with an elastic tread. What mattered to me, in that moment, the whole tribe of captains? should *they* disturb my equanimity?

The hill was nearly a mile from the house, and I reached it tired and breathless. Thoughts of Amelia, however, bore me up. I selected the best point of view for the cottage, so as to include a farmer and cow in the picture, cast one fond look toward the distant villa, and, muttering, "Amelia, 'tis for thee!" removed the lid of the lens; in 1 minute and 40 seconds I replaced it: "it is over!" I cried in uncontrollable excitement, "Amelia, thou art mine!"

Eagerly, tremblingly, I covered my head with the hood, and commenced the development. Trees rather misty—well! the wind had blown them about a little; *that* wouldn't show much—the farmer? well, *he* had walked on a yard or two, and I should be sorry to state how many arms and legs he appeared with—never mind! call him a spider, a centipede, anything—the cow? I must, however reluctantly, confess that the cow had three heads, and though such an animal may be curious, it is *not* picturesque. However, there could be no mistake about the cottage; its chimneys were all that

124

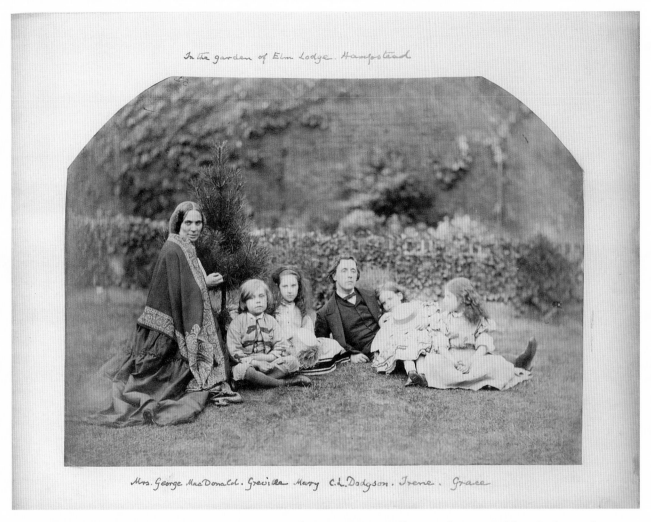

In the garden of Elm Lodge. Hampstead

Mrs. George MacDonald. Greville. Mary. C. L. Dodgson. Irene. Grace

*Mrs. George MacDonald (born Louisa Powell [1822–1902]) shared with Carroll a marvelous sense of the ridiculous and a gen-uine interest in the theater. It was she who strongly urged Carroll to publish* Alice's Adventures *when she read it in manuscript aloud to the MacDonald children, who responded rapturously. Mrs. MacDonald appears here with four of her eleven children and with Lewis Carroll, possibly taken by Carroll himself with a delayed timing device.*

could be desired, and, "all things considered," I thought, "Amelia will–"

At this point my soliloquy was interrupted by a tap on the shoulder, more peremptory than suggestive. I withdrew myself from the hood, need I say with what quiet dignity? and turned upon the stranger. He was a thick-built man, vulgar in dress, repulsive in expression, and carried a straw in his mouth; his companion outdid him in these peculiarities. "Young man," began the first, "ye're trespassing here, and ya mun take yourself off, and no bones about it." I need

hardly say that I took no notice of this remark, but took up the bottle of hypo-sulphite of soda, and proceeded to fix the picture; he tried to stop me; I resisted: the negative fell, and was broken. I remember nothing further, except that I have an indistinct notion that I hit somebody.

If you can find anything in what I have just read to you to account for my present condition, you are welcome to do so; but, as I before remarked, all I can tell you is that I am shaken, and sore, and stiff, and bruised, and that how I came so I haven't the faintest idea.

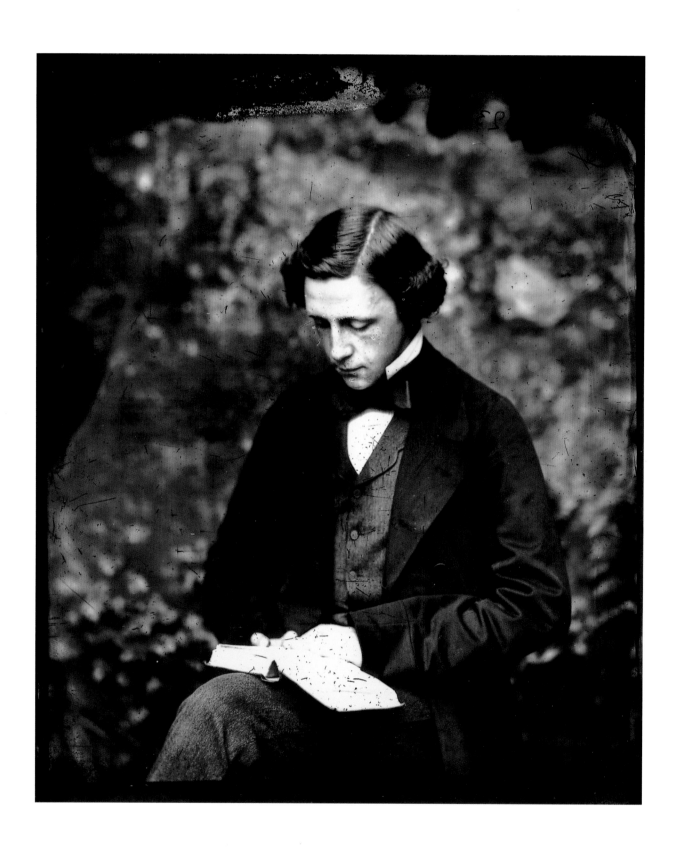

*Lewis Carroll, probably taken by his college friend Reginald Southey, ca. 1856. ". . . having been unlucky enough to perpetrate two small books for children,"* Carroll wrote, *"[I have] . . . been bullied ever since by the herd of lion hunters who seek to drag [me] . . . out of the privacy [I] . . . hoped an 'anonym' would give. . . . I so much* hate *the idea of strangers being able to know me by sight that I refuse to give my photo, even for the albums of relations."*

# THE PHOTOGRAPHIC MOMENT
# OF LEWIS CARROLL

*Mark Haworth-Booth*

In January 1856 Henry Cole, founding director of the South Kensington Museum, took up photography as an amateur and visited the annual exhibition of the Photographic Society of London. He bought twenty-two of the exhibits and thus began the world's first collection of photography as an art. Cole noted in his diary that he did not care for the costume-piece photographs.[1] Lewis Carroll, who also visited the exhibition, described the same kind of pictures with excitement: "There is a very beautiful historical picture by Lake Price called *The Scene in the Tower*, taken from life–it is a capital idea for making up pictures," he writes in his diary.[2] The photograph presumably portrayed the two young princes whose murder was ordered by Richard III. Carroll took enthusiastically to the idea of the child-tableau, and used it with skill–and even, it seems, with the enthusiastic participation of children–for much of his photographic career.

Carroll became an amateur photographer in March of 1856. His uncle, Skeffington Lutwidge, was a member of the Photographic Society and an elegant contributor to the albums of the Photographic Exchange Club.[3] Carroll was also photographed in 1856, probably by his Oxford friend Reginald Southey. The startling clarity and innocence of the portrait suggest the hallmarks of the photographic moment of the 1850s–a time of aspiration, inquiry, and sheer novelty.

Although he continued to use cameras until 1880, Lewis Carroll was always, in spirit, a photographer of the 1850s. It was a decade of suddenly accelerated progress, but also of definition. The medium achieved what we might now call "critical mass" at the Great Exhibition held in London in 1851. Fine photographs, gathered from international sources, were exhibited and displayed together for the first time. Some were shown in the Fine Art area–notably the calotypes by Samuel Buckle and the Edinburgh partnership of Hill and Adamson (whose images of children are among their most tender and beautiful). However, the majority were presented as part of the section on Philosophical Instruments (which

included a variety of types of apparatus, including telescopes, as well as cameras). Carroll recorded visiting the Great Exhibition, although his writings did not refer to seeing photographs. Also in 1851, Frederick Scott Archer published his revolutionary new collodion negative process. His invention combined the clarity of the French daguerreotype with the potential for multiple copies of the British calotype. It was to become the process used by Carroll for his entire career as a photographer. The first free-standing show of photographs was held at London's Society of Arts a year later.

In 1853 the Photographic Society of London was formed under the patronage of Queen Victoria, providing a meeting place and a journal and annual exhibitions of new work. In 1854 a lawsuit finally ended the patent restrictions under which the new medium had struggled since its announcement in 1839. In 1855 the French authorities mounted a spectacular showing of photographs at the Universal Exhibition in Paris, emphasizing the artistry of such pioneering heroes as Felix Tournachon ("Nadar") and Gustave Le Gray.

In 1857 photography was shown at the largest fine-art exhibition of the age, the Manchester Art Treasures Exhibition. In the same year Lady Eastlake published her now-famous essay on photography. She celebrated the medium as "a household word and a household want, used alike by art and science, by love, business and justice."[4] She defined it as something so new that it advanced on previous methods and evaded obvious classification. Photography was "neither the province of art, nor description, but of the new form of communication between man and man–neither letter, message, nor picture–which now happily fills the space between them." In 1858 Henry Cole staged the first museum exhibition of photographs. The opening at the South Kensington Museum was a glittering occasion, attended by Queen Victoria and Prince Albert. (The museum was subsequently renamed the Victoria and Albert.) Among the thousand or so exhibits were four photographs by Lewis Carroll, credited to him as C. L. Dodgson. It was the first, but also the last, time he showed in a public exhibition.

Carroll was arguably formed as a photographer before the 1850s were over. The medium had acquired high prestige and begun to crystallize into the domains of the amateur and the professional. The professional photographer Jabez Hughes paid a generous "Tribute to Amateurs" in 1863:

> Though the extensive diffusion and numerous applications of the art depend upon the professional, yet it must be always borne in mind that the original discoveries–marked improvements–are made by the amateur. . . . It is scarcely to be wondered at that the impulses forward should emanate rather from the amateur than the professional. The former pursues the art for *pleasure*, the latter for *profit*. The one can try all manner of experiments, and whether he succeeds or fails, he secures his object–agreeable occupation. The professional has all the energies directed to make things pay. He has too much at stake to speculate.[5]

A comparison of the photographs of children by Camille Silvy, a professional with a studio staff of forty, and those by Carroll, demonstrates the truth of Hughes's remarks. Silvy directed children, as he did their parents, with aplomb–plus a suitable choice of accessories. Carroll allowed himself and his sitters time and an imaginative space in which to participate and perform.

Carroll photographed as an amateur, but he made use of professional studios to store his negatives, to print from them as required, and sometimes to publish and sell his work (unattributed to him). The complexities of the medium in the heyday of the wet-collodion process were perhaps part of the attraction. To practice it as an amateur demonstrated a certain standing both in terms of intellect and income. To coat glass negatives with sticky wet collodion, immediately prior to exposure, required methodical manipulation and physical adroitness. His writings on photography, such as *Hiawatha's Photographing* and *A Photographer's Day Out* satirize the mediocre and inept. Also, "the conceptual framework of photography would have appealed to Dodgson's fertile and surreal imagination," as Roger Taylor has recently suggested:

> Through the ground glass of his camera his view of the world has been turned upside down and laterally inverted. The foreground took the place of sky; what lay on the right now appeared on the left; people hung upside down, large things were reduced in scale. Adjust the camera and small things were enlarged. Twiddle the focus of the lens and the outlines of solid objects dis-

solved until they disappeared from view. . . . Watching the glass plate develop offered a conundrum of reversed tones where white became black and black, white. In the world of photography the transient became permanent and the established, fugitive. Nothing was ever quite what it seemed.[6]

Despite his intense shyness, Carroll made contact with the British photographers whose interests connected most intimately with his own. In addition to the leading art photographers of the 1850s, Oscar Rejlander and Henry Peach Robinson, he sought out the pioneering women photographers who emerged in the early 1860s, Clementina, Lady Hawarden and Julia Margaret Cameron. Hawarden and Cameron were both more radical in their figure compositions, iconography, and lighting effects than Carroll, and both received substantial acclaim as a result of exhibiting their work. (Perhaps Hawarden's many pictures of mirrors, windows, young women, and doppelgängers held a special fascination for the future author of *Through the Looking-Glass*?)

In 1880 Carroll gave up photography partly because technical progress seemed to him mere decline. Instead of embracing the new possibilities afforded by the appreciably faster, and easier, gelatin dry-plate process, he stopped taking photographs altogether. He wrote to Meta Hogg (née Margaret Muir) on February 18, 1896:

> I confess to caring *very* little for these modern dry-plate photographs, the negatives of which have, as taken, all possible defects, & which have to be touched-up *all over* to be at all fit to print. They are *not* true 'photographs'– merely reproductions of a sort of miniature-painting– I myself took photographs (wet-plate) for about 25 years, and have got hundreds of beautiful results from entirely *un*-touched negatives. The enclosed would have been all the better for rather deeper printing: but, even as it is, it has a roundness & softness which no *human* handiwork can rival–The photos I took were principally of *children*, since, in my opinion, no photographs, except of *children*, are satisfactory. (That last clause is quoted from your letter, merely adding the word "except"!)[7]

There are, of course, many hideously retouched portraits of the dry-plate era. However, leading photographers of the 1880s, such as Peter Henry Emerson and Frederick Hollyer, used the new process with probity and finesse to make their *plein-air* and studio portraits. Carroll chose, for reasons of his own, to think of the new technique as debased.

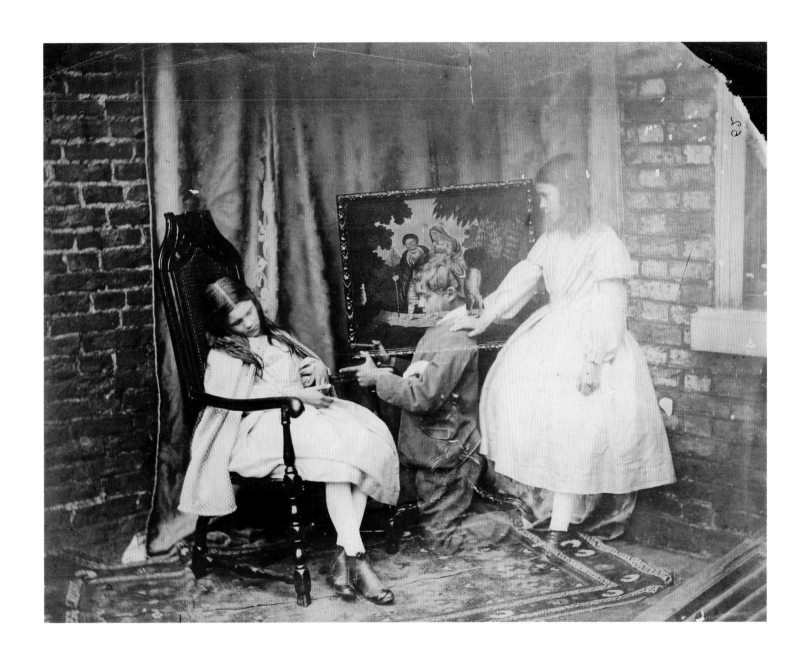

*"The Dream."* Carroll, striving for a ghostly effect, makes a double exposure of the children of John Barry (1820?–1856), a Yorkshire clergyman, and his wife Letitia Anna Mercer (1824?–1911). The son is John Warren Barry (1851–1920), later Justice of the Peace in Yorkshire. The daughters are Emily and Louisa.

An early posthumous evaluation of Lewis Carroll was published in the *Supplement to the Dictionary of National Biography* in 1901. The remarks on his photography are brief and erroneous, referring only to "Ruskin, Tennyson, Millais and Rossetti—of whom he has left valuable photographs, amateur photography having been successfully practised by him almost from boyhood" (actually from the age of twenty-four). The highly-reputed eleventh edition of the *Encyclopaedia Britannica* (1910–11) carried a longer article but made no mention of the photographs at all.

The first public assessment of Carroll as photographer was made by the American photographer Alvin Langdon Coburn, in 1915. Coburn, a Symbolist and later a Modernist photographer, was at home in the avant-garde artistic circles in New York and London. He staged an "Exhibition of the Old Masters of Photography" under the auspices of the Buffalo Fine Arts Academy at the Albright Art Gallery in January–February 1915. He exhibited works by the early Scottish photographers Dr. Thomas Keith and David Octavius Hill (omitting to credit Hill's partner, Robert Adamson); by Julia Margaret Cameron; and by Lewis Carroll. Coburn made exhibition prints from his own copy negatives after original photographs by Cameron and Carroll. The gum platinum prints after Carroll are larger than the originals, and glow like the dark masterprints of the Photo-Secession.

Coburn's selection of ten prints showed a variety of Carroll subjects, including male and celebrity portraits as well as "Miss Alexandra Kitchin" (as a tea merchant), "Mary Lott" and "Miss Alice Pleasance Liddell" (half-length, profile, seated on a chair).[8] "It is quite astonishing," Coburn wrote in the exhibition catalog, "how 'modern' in tendency the work of this little gathering of workers really is. Compare it with the average professional work of today and we will seem to have been progressing backwards all these seventy years."[9]

Coburn expanded on these remarks in an article for *The Century*, asking himself what qualities in the photographic medium drew together such a variety of pioneering talents.[10] He characterized his chosen quartet as "a painter, a surgeon, the wife of a philosopher, and a teller of wonder-stories, linked together by their attraction to a little black box." As a major portraitist himself, and in some ways very like Carroll, his answer seems to address the photographs here with particular acuteness:

Perhaps it is the humanity of it, for undoubtedly camera portraiture brings one in touch with the sitter in an intimate personal way not possible in the ordinary round of social functions. Perhaps, again, it is the mystery of it, for the strangeness of a negative flashing up in the developer, the absolute presentment of a living person, is a phenomenon that does not become commonplace even after a lifelong acquaintance, but rather tends to intensify in the quality of strangeness. But above all I believe the strongest incentive to the artist-photographer is the storing up of the contemporary truth of beauty for posterity. This looking forward to the welfare of a future generation is one of the finest and most hopeful traits we find in humanity in these ominous days.

The magnitude of Carroll's contribution to photography was fully recognized by Helmut Gernsheim, and its place in history assured by his activities as collector and scholar, notably in his monograph first published in 1949. My own mentor, Bill Brandt, referred to Carroll as "a photographer of children of genius." The Alice books played a role in Brandt's reinvention of the nude, and of the child portrait in the 1950s and early 1960s. In the 1970s Alice was re-interpreted by the artists Peter Blake and Graham Ovenden. They depicted her, in watercolour and silkscreen prints, as a sexualized adolescent. Their images are closer to the Lolita of Nabokov than the Alice of Carroll and Tenniel.

The iconography of Carroll's imagery of girl children has been probed in searching speculations by the scholars Carol Mavor and Lindsay Smith.[11] Their fine-grained and subtle analyses of Carroll's photographs and texts are as much of our time as Carroll's words and images are of his time. The state of childhood continues to be examined in powerful bodies of work by photographers such as Sally Mann and Jock Sturges, and by children themselves in the workshops held around the world by Wendy Ewald.[12] Some photographers have been engulfed by moral panic and threatened by the catch-all provisions of the Child Protection Act. A new film version of Vladimir Nabokov's novel *Lolita* has not found a commercial distributor in the U.S.[13] These debates take place against a disturbing background, in the late 1990s—the "insistent eroticising of children which is going on all around us."[14] All of this will, no doubt, be read back into an oeuvre begun in the first heyday of amateur photographers by a young Oxford don—the centenary of whose death in 1898 we mark with this publication.

# AFTER WORDS

*Roy Flukinger*

*You will think me very greedy, but, as the Americans say, "I'm a whale at" photographs.*
　　　　　　–Letter to Mary Mallalieu, November 11, 1891

Photography figures prominently in the Rev. Charles L. Dodgson's words, and words were something that the author took very seriously. He had cautioned more than one correspondent that all words mean something, and it is interesting to examine some of the meanings he brought to bear upon his favorite form of visual expression.

Throughout his writings, Dodgson characterized photography as many things: art, pastime, recreation, hobby, profession, devotion, entertainment, fascination, practice, chief interest, and his "one amusement." Other key expressions were similarly applied to the photographs themselves: pleasant things, dreams, moments, beauty, memory, likenesses, and—in a critical moment—"not much of a substitute for the live. . . ." As with writing, photography held Dodgson's creative and technical interests, complementing both his intellect and his passion.

Such seeming contradictions of mind and heart are seen throughout Dodgson's life and career, as most who have written about him have pointed out. He is the Oxford don and lecturer who struggled with a nervous stammer throughout his life; the scholar who published notable works on mathematics and logic but whose fame came through his authorship of some of our greatest works of fantasy and children's literature; the ever-constant gentleman who conducted himself with propriety at all times within the adult world but who would revert to an extroverted character and engage in antic play when in the company of little children; the "lion hunter" who sought out the famous for their autographs or as subjects for his camera but refused most requests (even, at times, from his family) for his own signature or portrait; a man serious in all matters of business, education, and family who was also among the most humorous in his constant perspective upon the world around him. Dodgson's duality of nature is nowhere more obvious than in the fact that he remained a careful correspondent and fastidious signator who throughout his own life inscribed his true name in nearly all instances but derived his fame and overwhelming popularity through his carefully maintained separate pen name–Lewis Carroll.

In one sense Dodgson and the relatively new medium of photography (it was only sixteen years old when he took it up in 1856) seemed to be made for each other, for both were the products of their age and subject to their own internal contradictions. From its beginning photography was subject to the duality of its birth–a "machine art" driven by human creativity but based upon the sciences of optics and chemistry. Even many of its chief pioneers–Louis Jacques Mandé Daguerre, William Henry Fox Talbot, and Robert Hunt, among others–wrestled with the ramifications of the very processes they had invented or improved.

During photography's first decades, the battle between art and science raged, as photographers, artists, learned societies, and the public in general all came to terms with this wondrous new means of recording, and interpreting, the world. Did it endanger art or merely serve it? Was it an art in itself or was its strength to be found in imitating other art forms? Did its very scientific origins preclude any artistic possibilities? Was its total accuracy of recording a blessing or a curse to portraiture? What was its true role within a society that believed that all good works should be capable of instruction and amusement? It seemed as if the conflict between head and heart that was so prevalent within photography was ready-made for such a complex individual as the Rev. Charles L. Dodgson. Perhaps his attraction to the medium was inevitable.

*Thanks for the photo. I can't honestly say I like it: it's one of those wretched printed-up negatives—an art which makes most professional photographs worthless: but I'm none the less grateful.*

–Letter to Charlotte Rix, March 22, 1887

Dodgson's twenty-five-year career in photography (1856 to 1880) covers that epoch which has often been called the golden era of nineteenth-century photography—a period largely evolving around the wet-collodion negative process and its corresponding positive albumen process. It therefore comes as no surprise that these were the techniques utilized and even championed by Dodgson throughout these productive years. The actual processes were complex, demanding technical expertise, practice, patience, and experience—qualities that were clearly integral to the Oxford don's character and intellect. Certainly the majority of his extant glass negatives and paper prints within the collections of the Harry Ransom Humanities Research Center (HRHRC) at The University of Texas at Austin display a mastery of the technique which only a committed and, indeed, devoted practitioner could accomplish.

Throughout this period, the albumen print was favored almost exclusively by amateurs and professionals alike. Using a binding solution of processed egg whites to hold light-sensitive silver salts onto the coated surface of a thin sheet of paper, the albumen process was a technically and commercially viable process that allowed the fixed, wet-collodion negatives to be placed in contact with the sensitized paper surface and printed out in the sunlight. The resulting prints were capable of relatively rapid processing and, if printed out and fixed correctly, possessed a lustrous surface and a broad tonal range. Dodgson maintained a strong advocacy for the albumen process even toward the end of his life, when he gave up making prints himself. He strongly disliked the dry-collodion negatives and the subsequent gelatin positive developing-out papers which ultimately replaced albumen prints.

Not surprisingly, there is a great deal of variety within the extant prints that have come down to us. Dodgson was a finicky technician who experimented with formulae and techniques; as a result, his prints show a variety of tonalities. At other times social circumstances or promises forced him to secure the best print possible from inferior negatives. (Frederick, the Crown Prince of Denmark, once wrote the Rev. George William Kitchin that he found

Dodgson's 1863 portrait of him to be too dark.) Also, Dodgson did not like the boredom of printing and often passed his negatives on to several commercial firms—among them Joseph Cundall & Co. (London), Hills & Saunders (Oxford), and Robinson & Cherrill (Tunbridge Wells). Whenever the latter were concerned they often found him to be a highly critical customer (much as John Tenniel and Harry Furniss found when they executed their original drawings for his books), who did not hesitate to criticize the prints and return them for reprinting. Still other hands were involved in executing the final prints and so an overriding variety replaces the consistency we might find with other Victorian photographers who did all their own printing.

Commercial firms were yet a further boon to Dodgson with the rise in popularity of the *carte-de-visite* portrait by the end of the 1850s. These small photographic portraits on a mount the size of a visiting card became both fashionable and popular throughout the world. They made the portraits of the famous and the familiar accessible to nearly all classes of society and became a commercial success for many firms through the 1860s and 1870s. Commercial studios often paid top dollar for the negatives of the famous which could be multiply printed, issued, and sold on their company's photo cards. Dodgson, long a photographer of the visages of the famous, found it on occasion profitable to provide negatives of the noteworthy (we know of Tennyson and Rossetti at least) to those companies for issuance on their *carte* or, later, cabinet card sets. Yet he often refused many of these same firms' requests to sit for his own portrait for this very same purpose.

There are other variations within Dodgson's prints that beg attention in passing. For one, the size of the untrimmed albumen prints (all contact printed from the original negatives) show that he worked with five plate sizes—ranging from 8 by 10 inches to 3¼ by 4¼ inches—throughout his life. Since he cites having bought cameras only thrice we may assume that changing plate backs might explain away the other negative sizes; however, since some of his diaries were lost or destroyed, he may have purchased other cameras we do not know about. We also find that a large majority of his prints have been cropped or trimmed, according to the artistic conventions of the day, into various shapes, including circles, ovals, and gothic arches. Ever the precisionist, Dodgson once figured

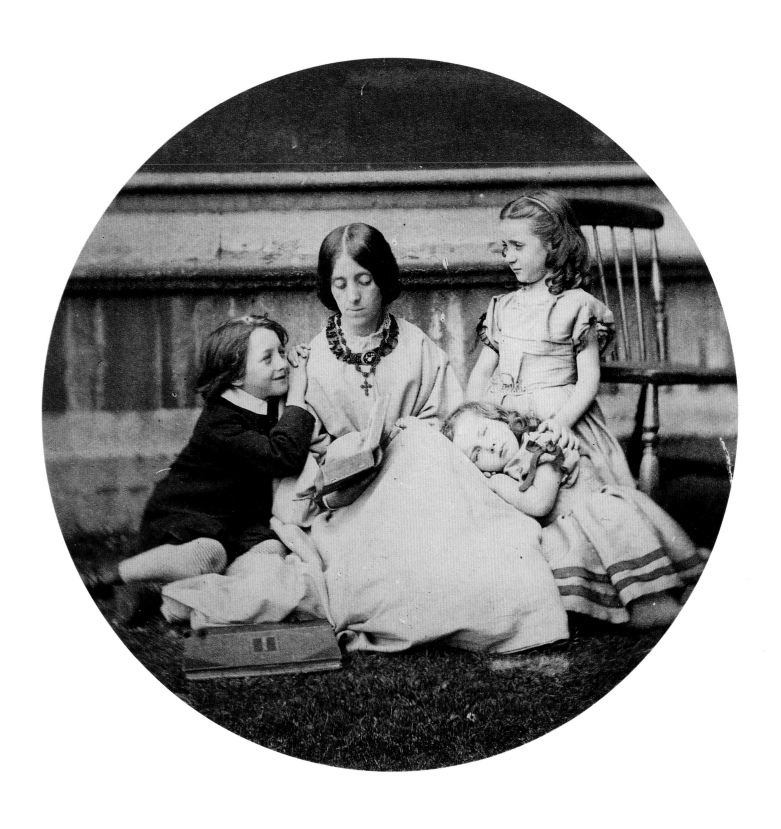

*Mrs. Hughes (Tryphena Foord) and three of the Hughes children. The son is Arthur; the daughters are Amy (1857–1915) and Agnes (1861–1948). The volume at Mrs. Hughes's feet appears to be one of Carroll's photographic albums.*

that it took him nine minutes to "finish" each print. Although he strongly disapproved of retouching, we do find some instances in which he attempted to apply pen to print very selectively to "improve" upon certain select details. Finally, there are a few instances in which he had works completely hand-colored or, in his correspondence, recommended appropriate colorists to others; and, while Helmut Gernsheim generously allows that this breach of his innate naturalism may have been due to his desire to flatter, it is also possible that he was still subconsciously influenced by the prevailing elaborate and richly colored styles of classicism and Pre-Raphaelitism.

*Of course I left something behind—always do: this time it was my album of photographs (and autographs). And we also forgot to get your names written in it. So will you please turn 2 or 3 pages on after "Mary Millais," and then sign your name in the same place in the page as she did, only about half an inch lower down, and then get Mary, Bertha, and Kate to do the same thing in the 3 following pages. And then will you send it by train to Croft Rectory, Darlington.*

*Thank you—much obliged.*

—Letter to Dymphna Ellis, July 29, 1865

The photographic album became Dodgson's chosen medium for keeping and presenting the gems of his photographic productivity. Indeed, save for the four prints he hung (under his real name, it should be noted) at the 1858 annual exhibition of the Photographic Society of London, he never again participated in any public showing of his work. Although there are several possible reasons for his decision to remain constant to the album format perhaps the simplest, most childlike one is found in the opening paragraph of *Alice's Adventures in Wonderland*:

Alice was beginning to get very tired of sitting by her sister on the bank, and of having nothing to do: once or twice she had peeped into the book her sister was reading, but it had no pictures or conversations in it, "and what is the use of a book," thought Alice, "without pictures or conversations?"

This decision was probably due, in part, to the preciousness of the photographs to their maker. Since the creation of the first paper-based photographs in the 1840s, families in particular tended to collect their important and trea-

sured images within the bound leaves of a single volume, there to store the images of their loved ones for later generations and to tell the story of their ancestors and heirs in some personal and customarily sequential fashion. Certainly Dodgson's earliest albums bear this familial imprimatur.

Albums also most likely suited Carroll's retiring personality. For, if his work had to be viewed, he would feel more comfortable with an intimate audience of one or two for album viewing than with a large public display. As he wrote in 1891: "I do not ever ask more than 2 ladies, at a time, for tea: for that is the outside number who can see the same photographs, in comfort: and to be showing more than one at a time is simply distracting."

Nor is their portability and personal intimacy to be discounted. As he traveled about with his camera gear he was able to collect the autographs of his sitters—be they child or celebrity—and show how their pictures would fit into his album alongside the faces he had already secured of his other subjects. Thus, the photographer could hold in hand the fruits of his labors, relate amusing tales and moving anecdotes about his sitters, and prepare the way for inviting others into this special realm of his industry and imagination. And, of course, the album's ability to amuse children and entrance their parents alike was also of great benefit in helping him secure even more of his precious, younger subjects for his lens.

In the auction of personal effects that followed shortly after Dodgson's death, thirty-three photographic albums were put up for sale. The catalogue gave no listings or other information about the volumes and many have never surfaced. By 1969 Helmut Gernsheim was able to account for only one dozen of the albums, all of which he examined firsthand.

The twelve that Gernsheim recorded are a very mixed group. To begin with, half of the albums bear Dodgson's original numbering scheme—nos. [A]I through [A]X, as assigned by him during a long organization of his photographs in 1875. However, there seems to be no system of organization among the volumes themselves—sizes, bindings, dates of apparent compilation and subjects often differ. Some have been carefully numbered and indexed in Dodgson's precise hand while still others have no key and bear no apparent written organization. In addition, his hobby of collecting autographs on the leaves is none too

consistent: sometimes signatures appear with no photographs, at other times just the reverse, while in many instances the two are happily wedded on a page.

There appear to be four basic types of album: family albums; collections of portraits and views; presentation albums; and, one compilation of the works of other photographers. It is very important to note that such categorizing must remain broadly based, as many of the albums–in that fundamentally organic and transitory fashion which only albums seem to possess–have had obvious removals of works or additions of non-Dodgson imagery over the decades. And just how many of these changes occurred before they left Dodgson's hands will probably remain undetermined.

Of the twelve Dodgson albums cited by Gernsheim, five are in his collection at the HRHRC at The University of Texas at Austin. Four albums are kept at Princeton University and two are retained at Christ Church Library, Oxford University. The final volume remains in private hands. More recent scholarship has turned up additional albums: one at the Royal Photographic Society, Bath; one at the National Portrait Gallery, London; and another in the Berol Collection at New York University.*

*Oh, Kitty, how nice it would be if we could only get through into Looking-glass House! I'm sure it's got, oh! Such beautiful things in it!* —Through the Looking-Glass and What Alice Found There

Sometimes, when examining one of Dodgson's albumen prints (especially the untrimmed or unmasked ones) one will notice a number–always inverted and usually near the edge of the photograph. It derives, of course, from the original glass-plate negative upon which Dodgson scraped in with a fine hand the number he had assigned each particular image. When you hold the original glass carefully in your hands and turn its emulsion side to reflect the light, you will generally find it there–the telltale mark of the artist/mathematician who, more than a century ago, created this entity which is now so rare and so preciously

held. As the emulsion side of the glass negative had to be in contact with the albumen printing paper to make a sharp as well as laterally corrected photograph, each number becomes inverted in the final positive print.

As few of these precious negatives survive to this day (there are nine in the Gernsheim Collection) it is difficult to experience firsthand the wonder of their significance. We do not know how many thousand Dodgson produced throughout his two and a half decades of creativity; no accurate final list has come down to us. Indeed, the mathematical precision of his recording was again contradicted by his artistic temperament, for we do know that there were many occasions upon which he weeded through his growing number of negatives and destroyed large numbers of the ones he no longer considered important. He also recodified and renumbered many of the plates he retained, and in a few instances gave some away. Undoubtedly only a well-researched and exhaustive *catalogue raisonné* can ever hope to give us some accurate sense of the true quantity and sheer variety of imagery he finally produced.

In the meantime, we have left to us the many original prints that still live on–the products of his own special looking glass, namely his camera. For what else is a camera but a special device for transforming and viewing our world? As any photographer who has slipped beneath the dark cloth and focused a portion of the world upon their ground glass can tell you, the eloquent mirror of the lens inverts and reverses that world–optically, mathematically, and magically. As the Rev. Charles L. Dodgson posed his subjects and viewed them through his lens he created his own special world and, emerging from the dark cloth as Lewis Carroll, brought back for all of us many special faces, scenes, and dreams from that wondrous dimension: where light and life, alongside imagination and truth, can flourish as they did within his very soul.

On the last day of 1856–the first year in which he practiced photography–he made the following resolution in his diaries: "I hope to make good progress in photography in the Easter Vacation. It is my one recreation and I think it should be done well."

After the words: twenty-five years of remarkable photographs. Promise kept.

*I am indebted to Edward Wakeling, whose research on Carroll's photographic albums is recorded in detail in his introduction to *Lewis Carroll's Diaries: the Private Journals of Charles Lutwidge Dodgson* (Luton: Lewis Carroll Society, 1993–).

Mar. 5/72.

O come to me at two today,
    Harcourt, come to me!
And show me how my dark room may
    Illuminated be.
Though gondolas may lightly glide,
    For me, unless you come,
No friend remains but cyanide
    Of pale potassium!

Though maidens sing sweet barcaroles
    (Whatever they may be)
To captivate Lee's-Reader's souls,
    Yet, Harcourt, come to me!
Yes, come to me at two today,
    Or else at two tomorrow,
Nor leave thy friend to pine away
    In photographic sorrow!

(L.D.)

*A previously unpublished letter from Carroll to Augustus George Vernon Harcourt (1834–1919), Lee's Reader in Chemistry at Christ Church. He and Carroll were close friends. Harcourt at times accompanied Carroll on visits to the Liddells. He also went along when Carroll and the Liddell sisters repeated the river trip to Godstow. Carroll photographed Harcourt and gave Mrs. Harcourt advice about fitting up her own photography room. Harcourt was one of the two witnesses of Carroll's will.*

# NOTES

## LEWIS CARROLL: PIONEER PHOTOGRAPHER

BY MORTON N. COHEN

1. "Lewis Carroll," *Strand Magazine* (April 1898).

2. Alice Liddell Hargreaves, "The Lewis Carroll that Alice Recalls," *New York Times* (May 1, 1932); also as "Alice's Recollections of Carrollian Days," *Cornhill Magazine* (July 1932).

3. "Reminiscences of Lewis Carroll," *Atlantic Monthly* (June 1929); also in *Windsor Magazine* (December 1929).

4. Unsigned review of the 1860 London Photographic Exhibition, *Illustrated Times* (January 28, 1860).

5. Ethel M. Rowell, "To Me He Was Mr. Dodgson," *Harper's Magazine* (February 1943).

6. "The Lewis Carroll that Alice Recalls."

7. Morton N. Cohen, ed., with the assistance of Roger Lancelyn Green, *The Letters of Lewis Carroll* (London and New York: Oxford University Press, 1979), p. 365.

8. *Letters*, p. 267.

9. See W. W. Bartley III, ed., *Lewis Carroll's Symbolic Logic, Part I and II* (New York: C. N. Potter, 1977); and Francine Abeles, ed., *The Mathematical Pamphlets of Charles Lutwidge Dodgson* (Charlottesville: Lewis Carroll Society of North America, 1994).

10. See particularly Iain McLean and Arnold B. Urken, eds., *Classics of Social Choice* (Ann Arbor: University of Michigan Press, 1995).

11. See G. C. Heathcote, *Lawn Tennis*, 1890.

12. *Letters*, p. 869.

13. Stuart Dodgson Collingwood, *The Life and Letters of Lewis Carroll* (New York: Century Co., 1898) Reprint (Detroit: Gale Research Co., 1967).

14. Roger Lancelyn Green, ed., *The Diaries of Lewis Carroll* (New York and London: Oxford University Press, 1953). Reprint (Westport: 1971), p. 109.

15. *Letters,* p. 447.

16. Ibid., p. 66.

17. Una Taylor, *Guests and Memories*, 1924, p. 312.

18. *Letters*, p. 434-5.

19. Ibid., p. 277.

20. "Lewis Carroll Interrupts a Story," *Children's Newspaper* (February 7, 1931).

21. Stuart Dodgson Collingwood, *The Lewis Carroll Picture Book*. Reprint, *Diversions and Digressions of Lewis Carroll* (New York: Dover Publications, 1961).

22. "Carroll and Photography," in *Literature and Photography*, ed., Jane M. Rabb (Albuquerque: University of New Mexico Press, 1995), p. 51.

23. *Diaries*, p. 245.

24. British Library: Carroll's unpublished Diaries, May 21, 1867.

25. Ibid., October 9, 1869.

26. MS: Huntington Library, California.

27. Private letter from Mrs. Diana Bannister.

28. *Letters*, p. 434.

29. "Lewis Carroll," *The British Journal of Photography* (July 1980).

30. *Lewis Carroll, Photographer*, rev. ed., 1969, p. 28.

31. "Books," *The New Yorker* (May 13, 1950).

32. "Carroll and Photography," p. 51.

33. *Masters of Photography: Lewis Carroll*, 1984, pp. 5, 8.

34. MS: Huntington.

## THE PHOTOGRAPHIC MOMENT OF LEWIS CARROLL

BY MARK HAWORTH-BOOTH

1. Mark Haworth-Booth, *Photography: An Independent Art. Photographs from the Victoria and Albert Museum, 1839–1996,* (London: Victoria and Albert Museum; Princeton: Princeton University Press, 1997), p. 40.

2. Helmut Gernsheim, *Lewis Carroll: Photographer* (London: Max Parrish & Co., Ltd., 1949). Revised edition (New York: Dover Publications, 1970), p. 36.

3. Grace Seiberling with Carolyn Bloore, *Amateurs, Photography and the Mid-Victorian Imagination* (Chicago and London: The University of Chicago Press, 1986), p. 135.

4. Lady Eastlake, "Photography" (unsigned article), *Quarterly Review* (1857), 101 p. 444 et seq.

5. Jabez Hughes, "A Tribute to the Amateurs," *The British Journal of Photography* (December 1, 1863), p. 466.

6. Roger Taylor, "'Some Other Occupation': Lewis Carroll and Photography," in *Lewis Carroll* (London: The British Council, 1998), pp. 32–33.

7. Private collection, England.

8. Two of Coburn's gum platinum prints were lent by George Eastman House, Rochester, NY, to *Carroll Through the Viewfinder*, an exhibition organized by the National Museums and Galleries of Wales, 1998: no. 18, Alice in profile, 1858 and no. 35, "Xie" Kitchin as a Chinaman, July 14, 1873.

9. The Buffalo Fine Arts Academy, Albright Art Gallery, catalog for the "Exhibition of the Old Masters of Photography," arranged by Alvin Langdon Coburn, January 30–February 28, 1913, p. 3.

10. Alvin Langdon Coburn, "The Old Masters of Photography," *The Century* (October 1915) 90:6, pp. 909–920.

11. Carol Mavor, "Dream-Rushes: Lewis Carroll's Photographs of Little Girls," in *Pleasures Taken: Performances of Sexuality and Loss in Victorian Photographs* (Durham and London: Duke University Press, 1995), pp. 7–42; Lindsay Smith, "'Take Back Your Mink': Lewis Carroll, Child Masquerade and the Age of Consent," *Art History* 16:3, pp. 369–385.

12. Chris Townsend, *Vile Bodies: Photography and the Crisis of Looking* (Munich and New York: Prestel in association with Channel Four Television Corporation, 1998), pp. 13–43.

13. Richard Goldstein, "The Beholder: The Christian Right's Porn Crusade," *The Village Voice* (New York: March 10, 1998) 43:10, pp. 32–37.

14. Joan Smith, "Do We Want All Our Children To Be Little Lolitas?," *The Independent on Sunday,* (London: March 26, 1998).

15. I am indebted to my friends and colleagues Susan Bright, John Hillelson, Roger Taylor, and Mike Weaver for their generous and timely help in preparing this essay.

# SELECTED BIBLIOGRAPHY AND SUGGESTED READING

Roy Aspin, *Lewis Carroll and His Camera* (United Kingdom: Brent Pubn., dist. by State Mutual Book and Periodical Service, 1989).

Isa Bowman, *The Story of Lewis Carroll Told for Young People by the Real Alice in Wonderland* (London: 1899). Reprint. *Lewis Carroll as I Knew Him* (New York: 1972).

The Buffalo Fine Arts Academy, Albright Art Gallery, catalog for the "Exhibition of the Old Masters of Photography," Arranged by Alvin Langdon Coburn, January 30–February 28, 1913.

Laura Casalis, ed., *Lewis Carroll, Victorian Photographer.* Introduction by Helmut Gernsheim (London: 1980).

Alvin Langdon Coburn, "The Old Masters of Photography," *Century Magazine,* (New York: 1915) 90:6.

Morton N. Cohen, ed., with the assistance of Roger Lancelyn Green, *The Letters of Lewis Carroll* (London and New York: Oxford University Press, 1979).

Morton N. Cohen, "Lewis Carroll's 'Black Art,'" in Colin Ford, ed., *Lewis Carroll at Christ Church* (London: National Portrait Gallery, 1974).

Morton N. Cohen, ed., *Lewis Carroll and the Kitchins* (New York: Lewis Carroll Society of North America, 1980).

Morton N. Cohen, *Lewis Carroll, Photographer of Children: Four Nude Studies* (Philip H. & A. S. W. Rosenbach Foundation, 1978).

Stuart Dodgson Collingwood, *The Life and Letters of Lewis Carroll* (New York: Century Co., 1898). Reprint (Detroit: Gale Research Co., 1969).

Stuart Dodgson Collingwood, *The Lewis Carroll Picture Book.* Reprint. *Diversions and Digressions of Lewis Carroll* (New York: Dover Publications, 1961).

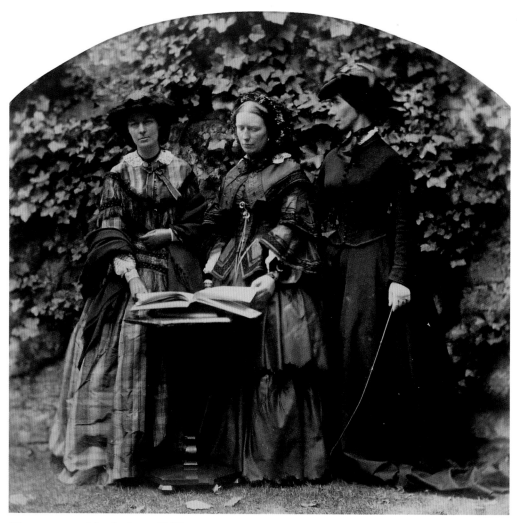

*Three women with a book, ca. 1857.*

Dennis Crutch, "C. L. Dodgson, Photographer and Artist," in *Mr. Dodgson: Nine Lewis Carroll Studies* (London: The Lewis Carroll Society, 1973).

Lady Eastlake, "Photography" (unsigned article), *Quarterly Review* (1857) 101.

Roy Flukinger, "Dodgson in Photography," in Robert N. Taylor, ed., *Lewis Carroll at Texas: The Warren Weaver Collection and Related Dodgson Materials at the Harry Ransom Humanities Research Center* (Austin: University of Texas, 1985).

Colin Ford, *Lewis Carroll, Photographer* (Bradford: National Museum of Photography, Film and Television, 1987).

Colin Ford, "Carroll Through the Viewfinder," in Karl Steinorth, ed., *Lewis Carroll Photographs* (Schaffhausen: Edition Stemmle, 1991).

Helmut Gernsheim, *Lewis Carroll, Photographer* (London: Max Parrish & Co., Ltd., 1949). Revised edition (New York: Dover Publications, 1969).

Jam B. Gordon and Edward Guiliano, "From Victorian Textbook to Ready-Made: Lewis Carroll and the Black Art," in Edward Guiliano and James R. Kincaid, eds., *Soaring with the Dodo* (New York: Lewis Carroll Society of North America, 1982).

Roger Lancelyn Green, ed., *The Works of Lewis Carroll* (London: 1965).

Roger Lancelyn Green, ed., *The Diaries of Lewis Carroll* (New York and London: Oxford University Press, 1953) Reprint (Westport: 1971).

The Grolier Club, catalog for an exhibition from the Jon A. Lindseth Collection (New York: The Grolier Club, 1998).

Edward Guiliano, "Lewis Carroll as Photographer," in Edward Guiliano, ed., *Lewis Carroll Observed* (New York: Lewis Carroll Society of North America, 1976).

Mark Haworth-Booth, *The Golden Age of British Photography 1839-1900* (New York: Aperture, 1984).

Mark Haworth-Booth, *Photography: An Independent Art. Photographs from the Victoria and Albert Museum, 1839-1996* (London: Victoria and Albert Museum; Princeton: Princeton University Press, 1997).

Carol Mavor, "Dream-Rushes: Lewis Carroll's Photographs of Little Girls" in *Pleasures Taken: Performances of Sexuality and Loss in Victorian Photographs* (Durham and London: Duke University Press, 1995).

Graham Ovenden, *Lewis Carroll* (London: Macdonald, 1984).

Graham Ovenden, *Pre-Raphaelite Photography* (London: Academy Editions, 1972).

Graham Ovenden and Robert Melville, *Victorian Children* (London: Academy Editions, 1972).

Lindsay Smith, "'Take Back Your Mink': Lewis Carroll, Child Masquerade and the Age of Consent," *Art History* 16:3.

S. F. Spira, "Carroll's Camera," *History of Photography* (1984) No. 8.

Roger Taylor, "'Some Other Occupation': Lewis Carroll and Photography," in *Lewis Carroll* (London: The British Council, 1998).

Ellen Terry, *The Story of My Life* (London: 1908).

*The Threepenny Review* (Winter 1996) No. 64, Carroll photographs and commentaries by Mindy Aloff, T. J. Clark, Ann Hulbert, Janet Malcolm, Lisa Mann, Adan Phillips, and Christopher Ricks.

Edward Wakeling, *Lewis Carroll's Diaries: the Private Journals of Charles Lutwidge Dodgson* (Luton: Lewis Carroll Society, 1993–).

Sidney Herbert Williams and Falconer Madan, *The Lewis Carroll Handbook*, rev. by Roger Lancelyn Green (1962) and by Denis Crutch (1970).

# ACKNOWLEDGMENTS

Sincere thanks to Sally Leach at the Harry Ransom Humanities Research Center at The University of Texas at Austin, for her collaboration; to all who loaned material for this publication; to Mark and Catherine Richards; and to Jon A. Lindseth, Pamela Schiele, Richard N. Swift, and Edward Wakeling for their assistance with the text.

# CREDITS

THIS PUBLICATION IS SUPPORTED BY THE Elgrebead Fund, with matching support from Steven Ames, Robert Anthoine, Ronald E. Compton, Barry H. Garfinkel, Sondra Gilman, Lynne and Harold Honickman, Mark Levine, and Barnabas McHenry.

This page and opposite: *Carroll's own illustration of "You are old, Father William," verse from* Alice's Adventures in Wonderland.

"I DO not believe GOD means us to divide life into two halves—to wear a grave face on Sunday, and to think it out of place to even so much as mention Him on a week-day. Do you think He cares to see only kneeling figures, and to hear only tones of prayer - and that He does not always love to see the lambs leaping in the sunlight, and to hear the merry voices of the children, as they roll among the hay? Surely their innocent laughter is as sweet in His ears as the grandest anthem that ever rolled up from the "dim religious light" of some solemn Cathedral? And if I have written anything to add to these stores of innocent and healthful amusements that are laid up in books for the children I love so well, it is surely something I may hope to look back upon without shame and sorrow (as how much of life must then be recalled!) when my turn comes to walk through the valley of shadows."

From " An Easter Greeting," by Lewis Carroll.

I am the Resurrection and the Life.

Charles Lutwidge Dodgson
(Lewis Carroll),
Fell asleep Jan. 14, 1898.

## A NOTE ABOUT THE LEWIS CARROLL SOCIETY

NORTH AMERICA: The Lewis Carroll Society of North America is a nonprofit organization devoted to the study of the life, work, times, and influence of Charles Lutwidge Dodgson (Lewis Carroll). The hundreds of current members include leading authorities on Carroll, collectors, students, and general enthusiasts. The Society meets twice a year at the site of an important Carroll collection and features well-known speakers and exhibitions. It maintains an active publication program and publishes a newsletter. Further information is available from the Secretary, Ellen A. Luchinsky, 18 Fitzharding Place, Owings Mill, MD 21117.

UNITED KINGDOM: The Lewis Carroll Society was founded in 1969 and it brings together people with an interest in Charles Dodgson, to promote his life and works, and to encourage research. The Society has an international membership of scholars, writers, collectors, and enthusiasts who simply enjoy reading the Alice books. Members receive the Society's journal "The Carrollian" issued twice a year, a quarterly newsletter called "Bandersnatch," and the "Lewis Carroll Review." The Society welcomes new members; please contact: Sarah Stanfield, Secretary, Acorns, Dargate, Near Faversham, Kent, ME13 9HG, England.

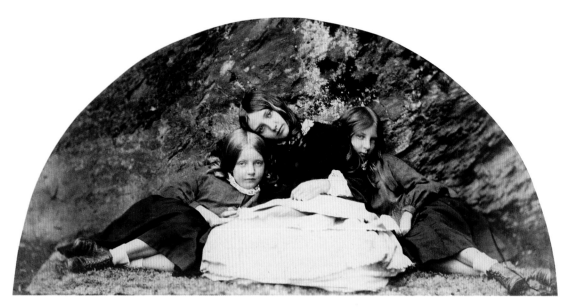

*Mary and Charlotte Webster and Margaret Gatey, Keswick, Lake District, 1857.*

Library of Congress Catalog Card Number:
98-85808
Hardcover ISBN: 0-89381-796-1

Color separations by Sfera Srl, Milan, Italy

Printed and bound by Artegraphica, S.p.A.,
Verona, Italy

The staff at Aperture for *Reflections in a
Looking Glass* is:

Michael E. Hoffman, *Executive Director*
Vince O'Brien, *General Manager*
Michael L. Sand, *Editor*
Stevan A. Baron, *Production Director*
Helen Marra, *Production Manager*
Lesley A. Martin, *Managing Editor*
Phyllis Thompson Reid, *Assistant Editor*
Jacqueline Byrnes, *Production Work Scholar*

Published in association with the

HARRY RANSOM
HUMANITIES
RESEARCH CENTER

"Reflections in a Looking Glass: A Lewis Car-
roll Centenary Exhibition" is presented at the
HRHRC at The University of Texas at Austin
from September 14, 1998 to January 5, 1999.
It will then travel to:

Equitable Gallery, New York City
February 12 to April 23, 1999

Fresno Metropolitan Museum,
Fresno, California
September 13 to November 28, 1999

Hyde Collection, Glen Falls, New York
January 15 to March 26, 2000

Jacket design by Carol Devine Carson

Book design by Wendy Byrne

First edition     10 9 8 7 6 5 4 3 2 1

Aperture Foundation publishes a periodical,
books, and portfolios of fine photography to
communicate with serious photographers and
creative people everywhere.
A complete catalog is available upon request.
Address: 20 East 23rd Street, New York,
New York 10010. Phone: (212)598-4205.
Fax: (212)598-4015. Toll-free: (800)929-2323.
Visit Aperture's website: http://www.aperture.org

Aperture Foundation books are distributed inter-
nationally through:

CANADA: General Publishing, 30 Lesmill Road,
Don Mills, Ontario, M3B 2T6. Fax: (416)445-5991

UNITED KINGDOM, SCANDINAVIA, AND
CONTINENTAL EUROPE: Robert Hale, Ltd.,
Clerkenwell House, 45-47 Clerkenwell Green,
London EC1R OHT. Fax: 44-171-490-4958

NETHERLANDS: Nilsson & Lamm, BV,
Pampuslaan 212-214, P.O. Box 195,
1382 JS Weesp. Fax: 31-294-415054

For international magazine subscription orders
for the periodical *Aperture*, contact Aperture Inter-
national Subscription Service, P.O. Box 14,
Harold Hill, Romford, RM3 8EQ, England.
One year: $50.00. Price subject to change.

To subscribe to the periodical *Aperture* in the
U.S.A. write Aperture, P.O. Box 3000,
Denville, New Jersey 07834. Tel: (800)783-4903.
One year: $40.00. Two years: $66.00